VOLUME ONE

NOWHERE TO CALL HOME

PHOTOGRAPHS & STORIES OF THE HOMELESS

PHOTOGRAPHY & TEXT BY **LEAH DENBOK** WITH TIM DENBOK

FriesenPress

Suite 300 - 990 Fort St
Victoria, BC, V8V 3K2
Canada

www.friesenpress.com

All royalties from this book will be given to:
Salvation Army
Barrie Bayside Mission Centre,
16 Bayfield St.,
Barrie, ON., L4M 3A4

Foreword written by: Major Doug Lewis
Introduction written by: J.T. McVeigh

ISBN
978-1-5255-1309-1 (Hardcover)
978-1-5255-1310-7 (Paperback)
978-1-5255-1311-4 (eBook)

1. PHOTOGRAPHY, PHOTOJOURNALISM

Distributed to the trade by The Ingram Book Company

VOLUME ONE

NOWHERE TO CALL HOME

PHOTOGRAPHS & STORIES OF THE HOMELESS

To my mentor, Joel Sartore,
who helped me believe in myself.

—Leah

Amazing photography. It's said that a picture is worth a thousand words, and that expression is exactly suited to describe Leah's work. She poignantly captures the depth and humanity of the individual that she beholds in front of her lens.

—Bruce Rivers
Executive Director, Covenant House Toronto

Leah's photographs are direct and honest, revealing the homeless not as a *type* but as individuals ... She fills the frame with their eyes, their faces, their pain and isolation in such a way that we cannot be distracted from what we see. Her language is one of light and shadow reinforced by hard contrast and graininess that symbolizes their lives. Her photographs are a testimony to the sensitivity and maturity of this young and talented photographer.

—John Jacquemain
Photographer and author

Leah's visual storytelling is a raw portrayal of what it's like to be homeless in Canada. These are the faces of just some of the estimated 235,000 men, women, and children who do not have a safe place to call home. Her photographs encapsulate the stories of our country's most vulnerable individuals.

—Patricia Mueller
Chief Executive Officer, Homes First

In my years of experience working with the homeless, I have yet to see a visual display of heartfelt motivation to study this population and bring them to life as this display that Leah has captured. She portrays this population in her book, *Nowhere to Call Home: Photographs and Stories of the Homeless*, and their circumstances as individuals with artistry and passion for life, and she does it well. She has both "humanized the homeless" and certainly "drawn attention to their plight."

—Doris Sensenberger
Executive Director, Home Horizon

It is easy to simply walk by the men and women we see struggling for survival on our streets and comfort ourselves with the idea that they are merely *the homeless*— somehow different from you and me. But there is no way to look at Leah's stunning portraits without being deeply moved by the humanity and individuality of her subjects. That realization fosters our own humanity, our empathy, our community. At a time when we seem to be increasingly defined by our differences, nothing could be more important.

—Dave Giffen
Executive Director, Coalition for the Homeless

Thank you for this personal view of homelessness. So often we walk by and ignore people living on the streets. Your pithy text reminds us that we all have stories worth telling. I hope your stories, coupled with the beautiful photos, will prompt us to take the time to listen to our fellow citizens more intently.

—David Raycraft
Director of Housing Services, Dixon Hall Neighbourhood Services

PREFACE

Homelessness is a serious problem, not just in Canada but throughout North America. Each day in Canada thousands of men, women, and children try to survive on the streets—often in harsh conditions—because, unlike you and me, they have nowhere to call home. This occurs despite the fact that Canada is one of the richest countries in the world. It's the same in the United States. How can this happen in two G7 nations? We must stop this madness! Together, I believe we can—if only we can find it in our hearts to care. Let me tell you why I care.

My mother, like the people you will see in the pages of this book, was once homeless. When she was only three years old a police officer found her wandering alone on the crowded, dirty streets of Calcutta, India. Knowing that Saint Teresa (formerly Mother Teresa) never turned a child away, she was taken to the orphanage, Nirmala Shishu Bhavan. There my mother was raised by Saint Teresa until, at the age of five, she was adopted by a couple from the small town of Stayner, Ontario. I care, then, because Saint Teresa cared—cared enough to open up her home to a penniless little girl who would have likely died of malnourishment or disease.

I first began photographing the homeless two years ago when I was fourteen. My dad, who always accompanies me on my photo shoots, stumbled upon some photographs of the homeless online taken by the British photographer Lee Jeffries. "Hey, Leah," he said, "look at these!" I did and was hooked. My photographs, admittedly, pale in comparison to those of Jeffries, who is considered one of the best portrait photographers in the world. But I believe I'm improving each year that goes by. I produced this book of photographs only because my mentor, Joel Sartore, a National Geographic photographer and Fellow, thought that they were good enough. I hope you are of the same opinion.

Just as my mother is deeply indebted to Saint Teresa, I owe a lot to Joel. This is the reason I've dedicated this book to him. If it wasn't for Joel, I probably would have quit photography at the age of twelve—mere months after I had begun. I was convinced that, as a photographer, I was a lost cause. Fortunately, he saw some

potential and persuaded me not to give up. It was also with his encouragement that I first began to focus on portraiture and, then, photographing people who live on the streets.

I hope, through my photographs and stories, to humanize the homeless. I want to capture their dignity as human beings. So often, the homeless are viewed as sub-human creatures one dare not approach, let alone talk to. I want to change this perception of them.

I invite you to look into the eyes of the homeless individuals you will see on the pages of this book. They tell a story—one of loneliness, fear, grief, regret, and rejection. But they also tell a story of hope, expectation, and gratitude. In short, they communicate emotions common to *all* human beings.

I also hope, with my photographs and stories, to shine a spotlight on the plight of homelessness. Contrary to what many think, few homeless people are on the street by choice. The problem is more often than not affordable housing. Dave Giffen, executive director of the Coalition for the Homeless in New York, says:

> The vast majority of those who are homeless are there simply because of the lack of affordable housing. It's exceedingly rare for people to choose to be on the streets, unless they have no other rational options. In nearly 30 years of involvement in this work, I've yet to meet *anyone* who would turn his or her back on the offer of an affordable place to live. We must always work hard to dispel the myth that people are homeless by choice, when no choice in fact exists.

At the end of this book, you'll find a list of organizations throughout North America that help the homeless. My hope is that you will be so moved by the photographs and stories in this book that you'll support one or more of these organizations. Together, let us stop the madness of homelessness in Canada and the United States!

—Leah Denbok (with Tim Denbok)

FOREWORD

William Booth, the founder of the Salvation Army, sent out a one-word telegram to his officers. It simply said OTHERS. "It's not about us." He later explained to his officers, "It's about others."

So who are these others? What do they look like? As you read through *Nowhere to Call Home*, you will realize that they are just like you and me: individuals striving to exist in a world where economic status is everything.

As executive director of the Salvation Army's Barrie Bayside Mission Centre, a homeless shelter for men with a Family Services and Community Meals Program, I see people on a daily basis who, whether because of the busyness of the general population or a willingness on its part to ignore the plight of these individuals, have become almost invisible. They are, nevertheless, a very real part of our society.

Through *Nowhere to Call Home*, you will be given a new awareness and an insight into what takes place in the life of someone who finds it necessary to live on the street or in shelters. This is not what they planned or wished for, but this is their station in life right now.

Leah Denbok has captured the real images of homelessness. Through these portraits, you will see deep into the souls of the people who regularly walk our streets, sometimes aimlessly, as they search for a feeling of belonging. And that is why the Salvation Army does what it does.

William Booth, in his final farewell address, penned these words:

Whlie women weep, as they do now, I'll fight. While little children go hungry, as they do now, I'll fight. While men go to prison, in and out, in and out, as they do now, I'll fight. While there is a drunkard left, while there is a poor lost girl upon the street, while there remains one dark soul without the light of God, I'll fight— I'll fight to the very end!

May this book inspire you to fight to alleviate the pain and suffering of those wanting to belong, of having somewhere to call home, and people to call friends.

—Major Doug Lewis
Executive Director, Barrie Bayside Mission Centre

All royalties from this book will be given to:

Salvation Army
Barrie Bayside Mission Centre

INTRODUCTION

For the 30-plus years I have worked as a photojournalist, poverty, mental health, and homelessness remain topics that are rarely brought up in a newsroom unless something, usually tragic, has taken place.

It is a story that lives in every town and community, not just in big cities but anywhere.

The story isn't homelessness; it's about people. People who have families, who had ambitions and, whether by their own hand or circumstance, have found themselves on the wrong side of the ledger.

And the greatest crime is that they are ignored. Maybe they are too much like ourselves, and we don't want to see. Leah Denbok wants you to see.

Her photography, her high-contrast images bring out the lines and wrinkles, like a journal of lives hard-lived by the people she photographs.

Her work brings a level of empathy that is far beyond her age; she is only a teenager, and her curiosity and maturity about the human condition is admirable.

This book contains small stories about the subjects, but you don't need them. Just look at the faces and think of ways where true solutions may be found.

—J.T. McVeigh
Editor-in-Chief, Enterprise-Bulletin

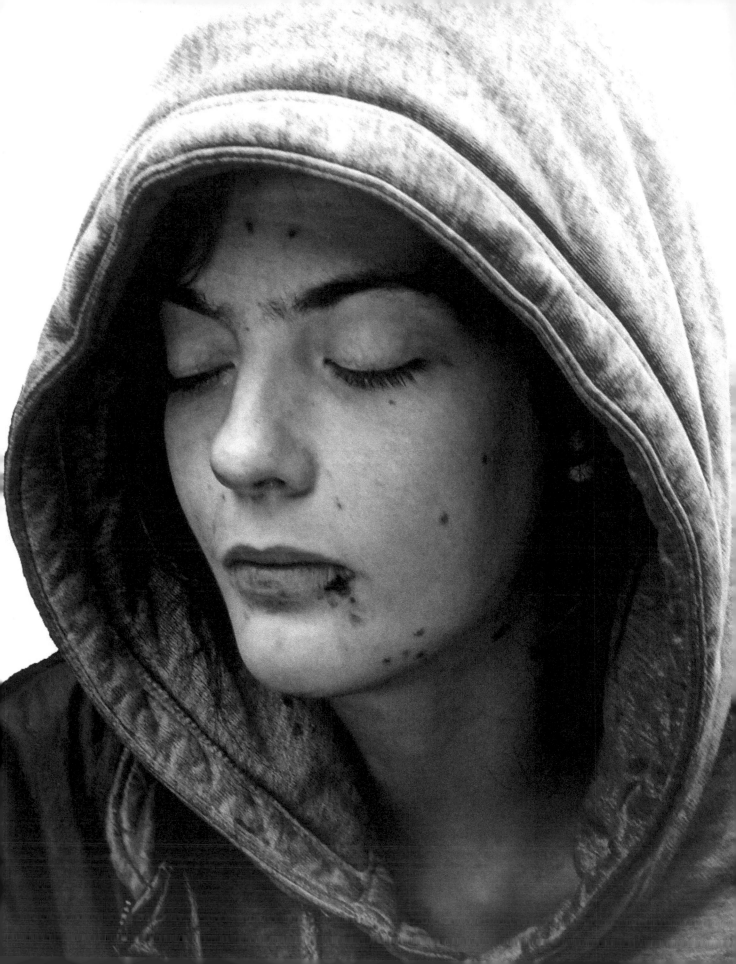

LUCY

Lucy once had big dreams. "I've always been a writer, like, journaling and short stories and what not," she told me and my dad. "But now, it's hard to keep up with the stuff you even love, because it's just survival."

Lucy is an opioid addict. "I've been an opioid addict since I was fourteen, but it was always manageable. I, like, had a job. I was going to school. I had my own place to live. I had interests." However, one day, she reached the point where her addiction took over her life. She found herself with no job, no schooling to speak of, and no place to live.

Life on the street is harder for Lucy than for most homeless people. "I have a hard time with sleeping outside and stuff like that," she said, her eyes closing repeatedly as we interviewed her. "A lot of people, like, you know, they adjust...."

Fortunately, Lucy may soon be leaving the streets she hates so much. "It's transitional housing." Her voice held a note of excitement. "And I'm, like, moving in, in, like, three days. So, I get my own bathroom, and I share a kitchen, and I'll have my own bedroom."

When I posted this photo of Lucy online, someone responded with the comment "Tragic beauty." Lucy's features look like they could have been sculpted by Michelangelo's chisel.

HOMELESS MAN AND DOG

I tried several times while photographing this homeless man and his dog to capture the obviously close bond between them. However, try as I might, all of the photos seemed too posed. It wasn't until we were walking away that my dad happened to look back and saw the man with his arms wrapped around his dog in a spontaneous, loving embrace, their foreheads resting affectionately against each other.

I quickly ran back and began snapping pictures. Later, when I walked away once more, I did so with the satisfaction of knowing I had just captured a special moment on film between a homeless man and his best friend.

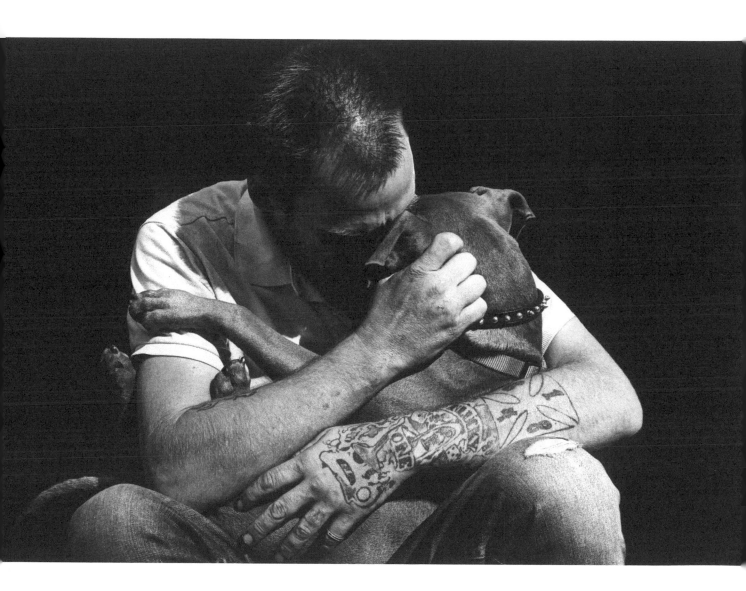

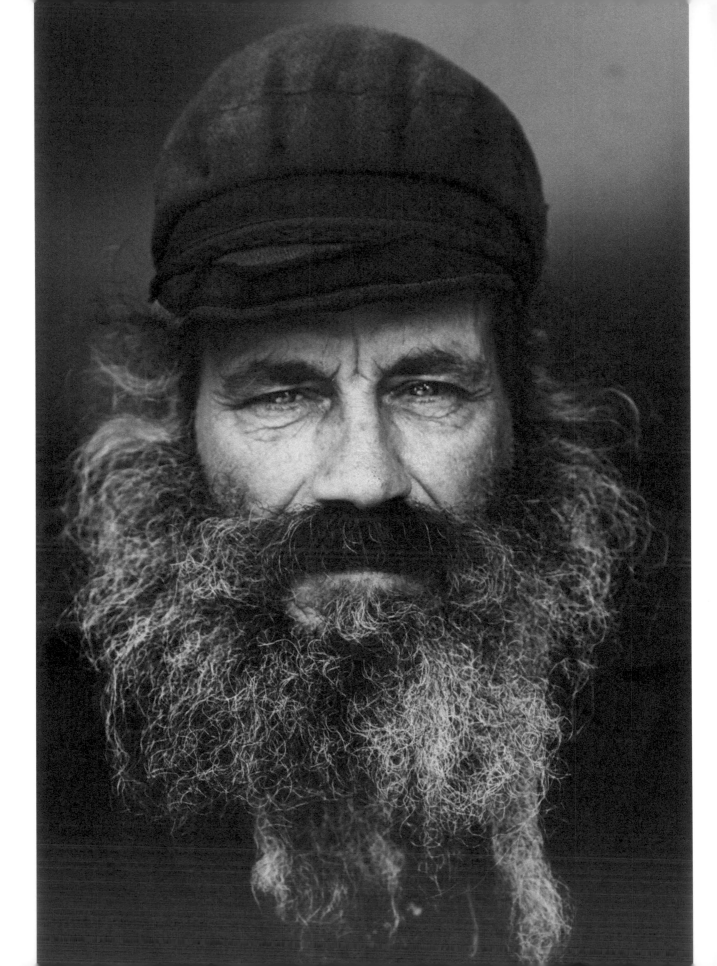

JOHN

When my dad and I first spotted John, he was sitting beside the Eaton Centre in Toronto. He was dressed appropriately for the weather in a blue winter coat and cap. With his shaggy grey beard and striking blue eyes, he reminded me of the characters in the novels by the Russian writer Solzhenitsyn.

My dad approached John and asked him about modeling for me. "I was wondering if my daughter, Leah, could take your photograph?"

"Why?"

"She's planning to study photography at university and is trying to build up her portfolio."

"Not good enough."

"Well, lately, she's been photographing homeless people in several North American cities, such as Kitchener, New York, and Toronto."

"Still not good enough."

"She hopes, with these photographs, to both humanize the homeless and draw attention to their plight."

"Okay."

Living on the streets has taken its toll on John.

"I look completely different now than I did even five years ago. My old friends wouldn't even recognize me anymore," he said, a note of sadness in his voice.

 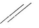

JANICE

The sun was beginning to set upon another hot August day in New York City, and it would soon be too dark to take photographs. As my dad and I walked past a small park, we saw a little old woman standing hunched over a park bench. She was very meticulously covering the bench with newspapers. Perhaps she was preparing her bed for the night.

After introducing ourselves, my dad asked if I could take her picture. After hesitating a moment, Janice said I could. She may have been self-conscious or sensitive to the bright sunlight, for she seldom raised her head or opened her eyes. Nonetheless, she was very friendly and clearly enjoyed our attention.

Janice talked very fast the whole time and looked down while speaking, so we had difficulty understanding her. We did catch, however, that she was aboriginal and had lived in New York City her whole life.

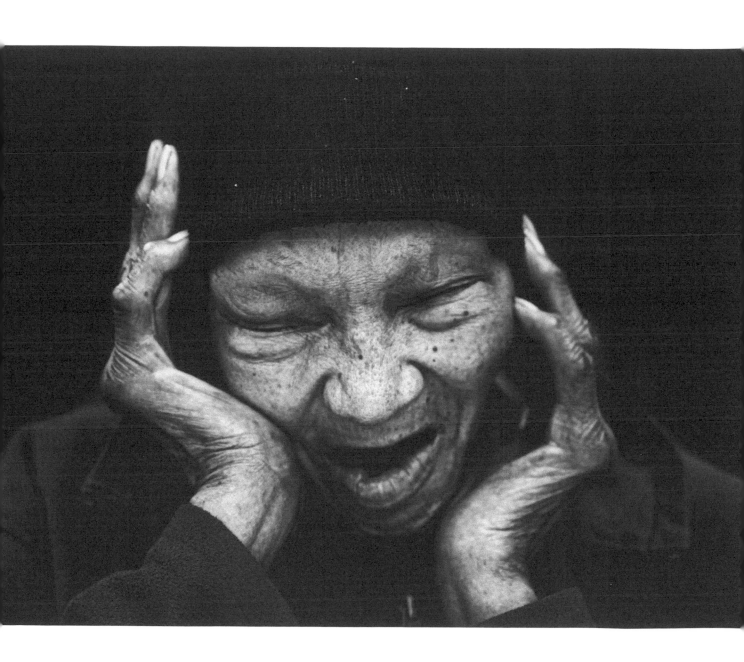

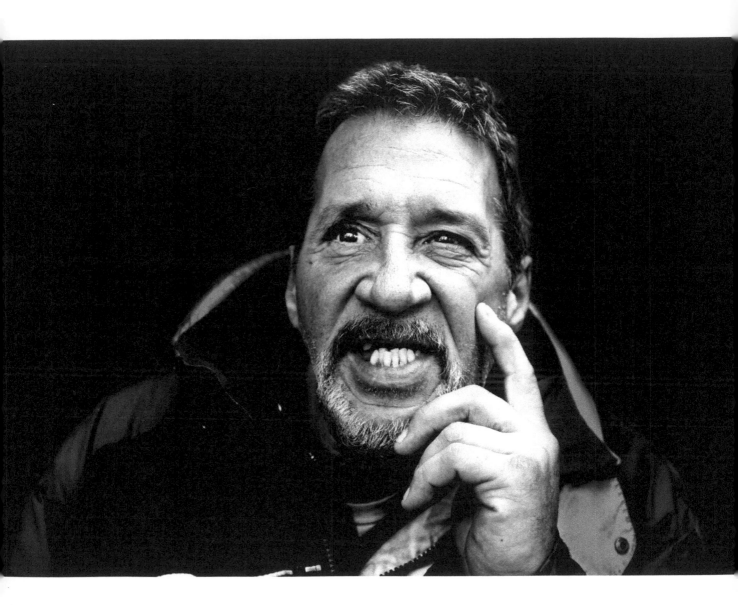

RONNY

The circumstances that led to Ronny getting "kicked to the curb" (literally) are sad enough to melt the hardest heart. It began with the death of his six-year-old daughter from cancer. Then his wife, unable to cope, took her own life. This sent Ronny's life spiraling out of control. To numb his pain, he took to drugs and alcohol, ringing up a bill of almost $500 a week. In Ronny's own words, this "left me in debt, living paycheck to paycheck, and in other words totally _____." The tipping point was when he arrived home to find his doors padlocked. He had nowhere to go but the streets.

Realizing the damage that drug addiction had done to his body, not to mention his wallet, Ronny managed to kick the habit. But, despite this personal victory, he was still struggling to get back on his feet.

We came across Ronny panhandling at the corner of Yonge and Dundas in Toronto. When we met him, he'd only been "on the job" for 16 days—and hated every minute of it.

"People are very rude," he said. Though some are kindhearted—like the security guards of a nearby store who often bring him lunch—most treat him as if he were a thing, rather than a person. When I took Ronny's photograph, he was sitting beside a garbage can. Perhaps this reflects the indifference and unkind words of the passersby who often make him feel as if he's trash.

"These are the people who make me feel like nothing."

GORD

I've photographed Gord a couple times. The first time was when CTV did a story about me and they showed me taking Gord's picture. When we ran into Gord again, a few months later, as he stood outside the Barrie Bayside Mission Centre, he was kind of embarrassed about being on TV.

"All of my friends say, 'There's the movie star!'"

Nonetheless, when I asked to take photos of him again (since the first ones hadn't turned out), he graciously consented to go through the ordeal once more.

It was a pleasure meeting Gord. He was friendly, intelligent, and articulate. Among other things, he expressed his concern "that mingling with people who are mentally ill, as much as I do, will have a negative impact on my own mental stability."

Gord knows firsthand how substance abuse can ravage one's life. Those who abuse their bodies in this way to "escape reality, when reality gets too tough to handle" have long been a part of his life. However, he's determined to stay clean.

Gord proudly told us that he recently got a roofing job. His goal is to save enough money to buy his own home.

"Something small, just enough for one—maybe with a gas fireplace, but I won't push my luck."

When we asked Gord what led to his being at the centre, he sheepishly admitted it was because of a spat with his sister.

"Unfortunately," he said dejectedly, "feelings got hurt and words were said that can't be taken back."

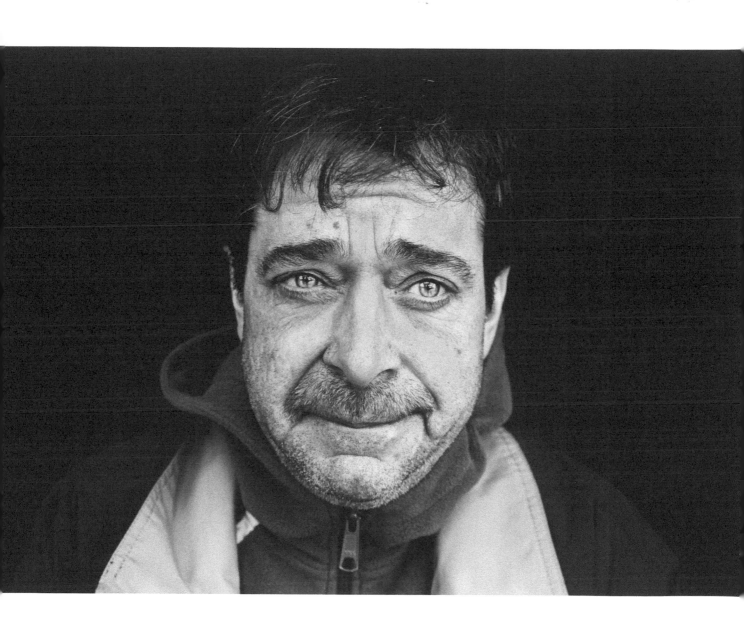

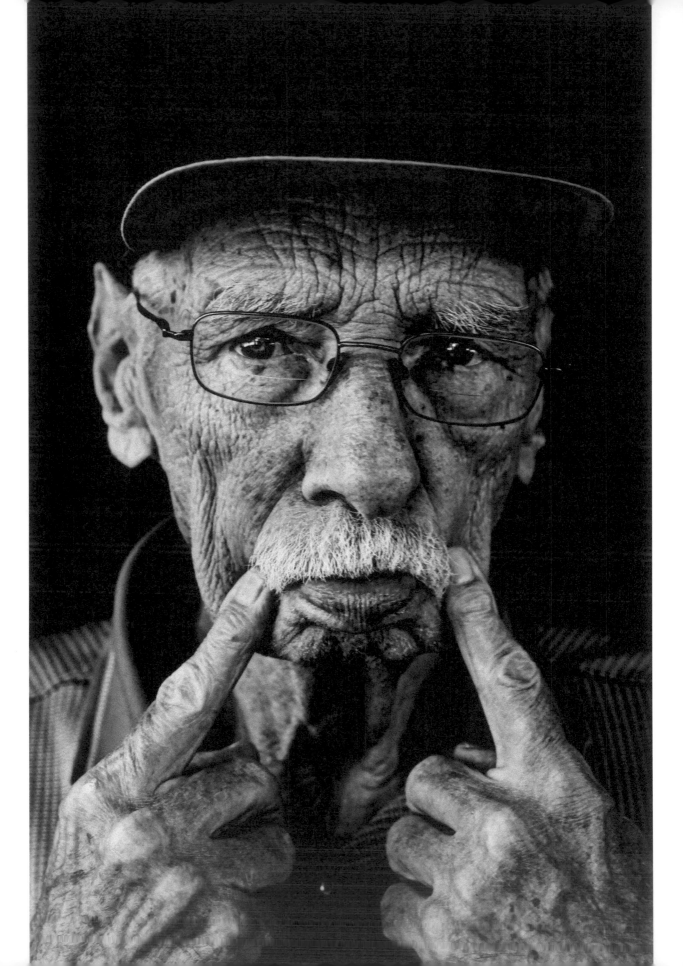

JACK

When my dad and I came across Jack, he was sitting by himself on a bench on King Street West, a couple blocks east of the Kitchener City Hall. It's an area frequented by homeless people.

My dad introduced us and asked Jack if I could photograph him. Jack seemed troubled by the question.

"It will only take about five minutes," my dad said.

Still Jack hesitated. Finally, he said, "Do I have to take my clothes off?"

After my dad assured him I just wanted to take his portrait and he didn't need to disrobe, Jack was much relieved and said simply, "Okay."

However, no sooner did I begin taking pictures than Jack began hamming it up. So maybe he had just been kidding when he asked if he had to pose in the buff.

BRYAN

When my dad and I spotted Bryan, he was sitting, looking lonely and forlorn, outside of the Eaton Centre in Toronto. It was a cold, bitter November day.

Words, we discovered, do not come easily to Bryan. However, he did tell us that he was 53 years old. He also said he had not talked to his family, who live in nearby Scarborough, for six years. He was staying at the Seaton House homeless shelter.

When we asked Bryan what made him happy, he said, "Nothing."

He, similarly, replied to our other questions with one or two words. It soon became evident that Bryan wasn't enjoying the attention we were giving him, and we said goodbye.

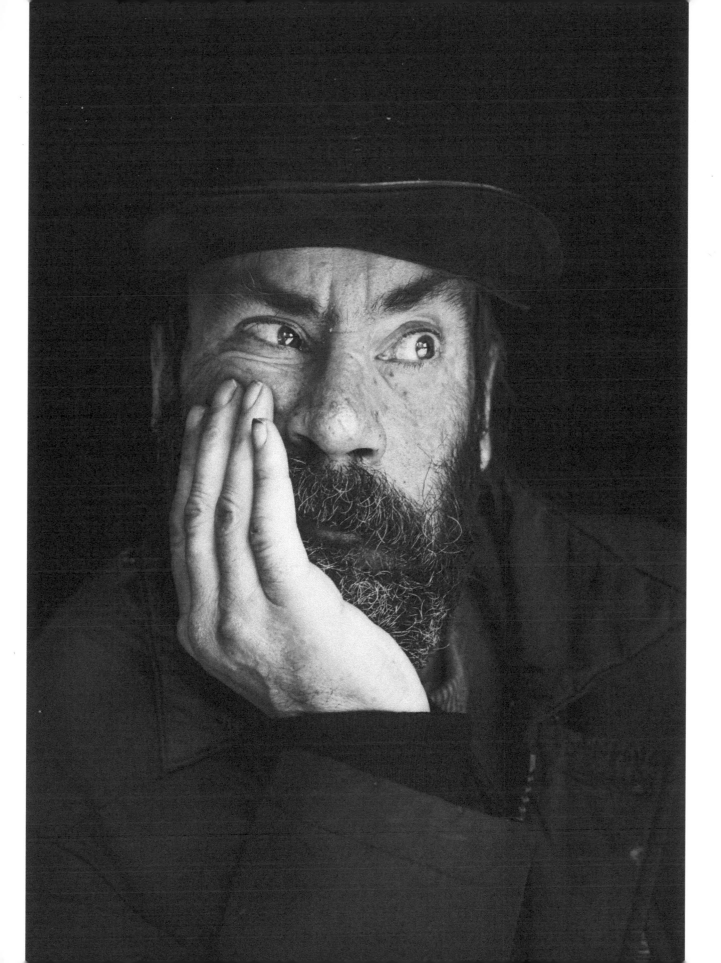

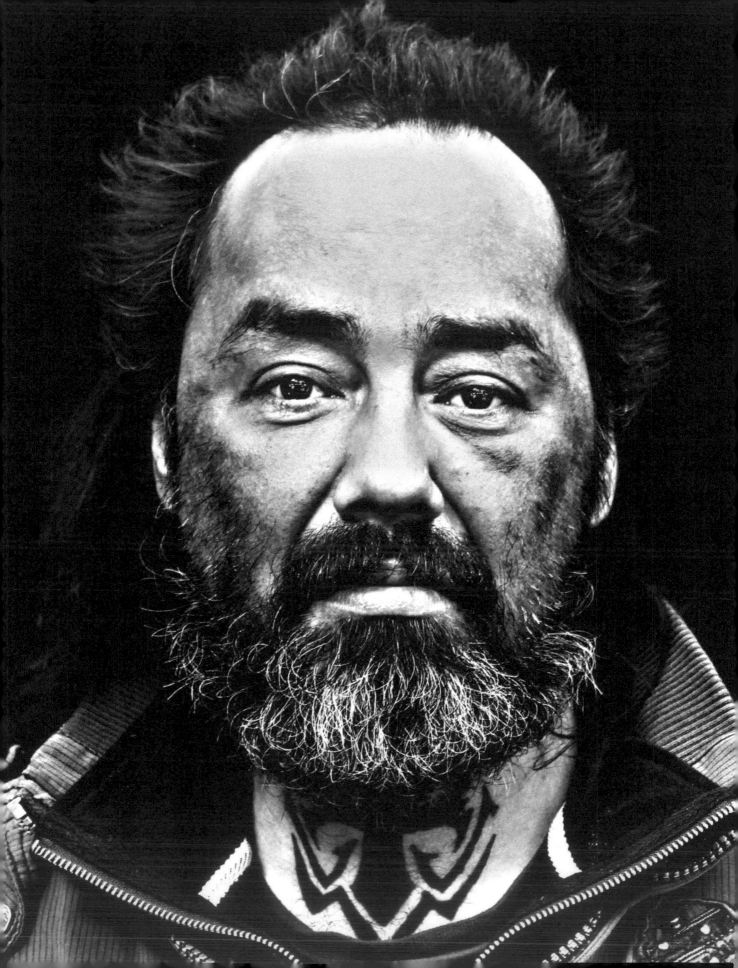

PAT

A small group of First Nations people were chatting one day beside the World's Largest Bookstore in Toronto (since demolished) when my dad approached one of them, a rather large young man who appeared intoxicated. My dad asked if he'd be willing to model for me for $10. He told us he wanted $20. When my dad said no, the man responded by closing his eyes for the duration of the photo shoot.

We had better success with Pat. Although he said virtually nothing during the photo shoot, unlike his friend, he was friendly and cooperative. Like many homeless individuals that I've had the privilege of photographing over the past couple years, Pat carried himself with a sense of dignity.

HEATHER

Life has not been easy for Heather. Although she looks no more than 25 years old, Heather said she has spent "the better part of sixteen years moving from street corner to street corner, in the hope of finding employment and a roof over my head."

On this particular chilly December afternoon, she was panhandling on the busy intersection of Yonge and Dundas in Toronto. With a hoodie pulled over her head and a blanket wrapped around her, Heather was doing her best to keep the warmth in and the cold out.

Despite the bleak situation she found herself in, Heather's outlook on life was surprisingly positive. One reason for this was the personal victory she'd recently won over drugs. Now, she said, "I just turn around and walk the other way."

As the mass of people streamed by Heather, many carrying bags full of Christmas gifts, she greeted them with "Happy Holidays!" or "Merry Christmas!" A few responded in kind. Some even gave her change. Most ignored her.

Though I asked Heather to *not* smile for the camera she did anyway. Smiling is obviously second nature to her—to not smile would probably feel unnatural. The last thing Heather did as we walked away was to smile and say, "Merry Christmas!"

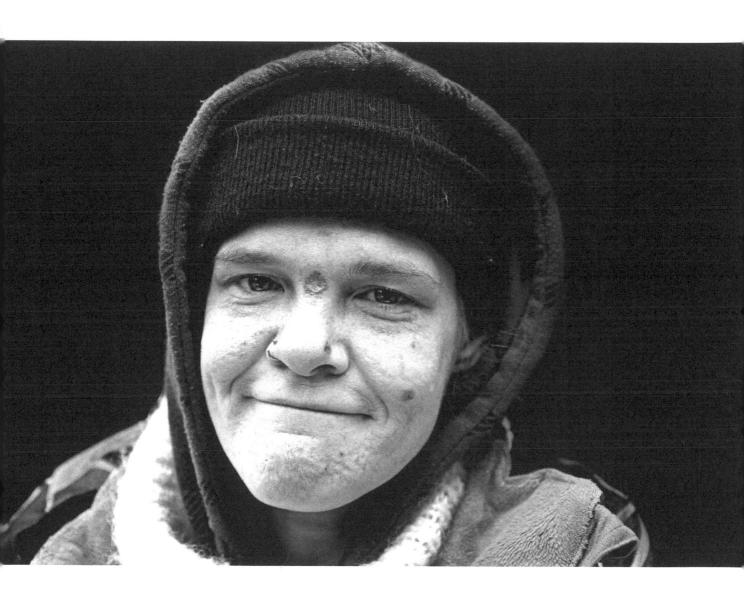

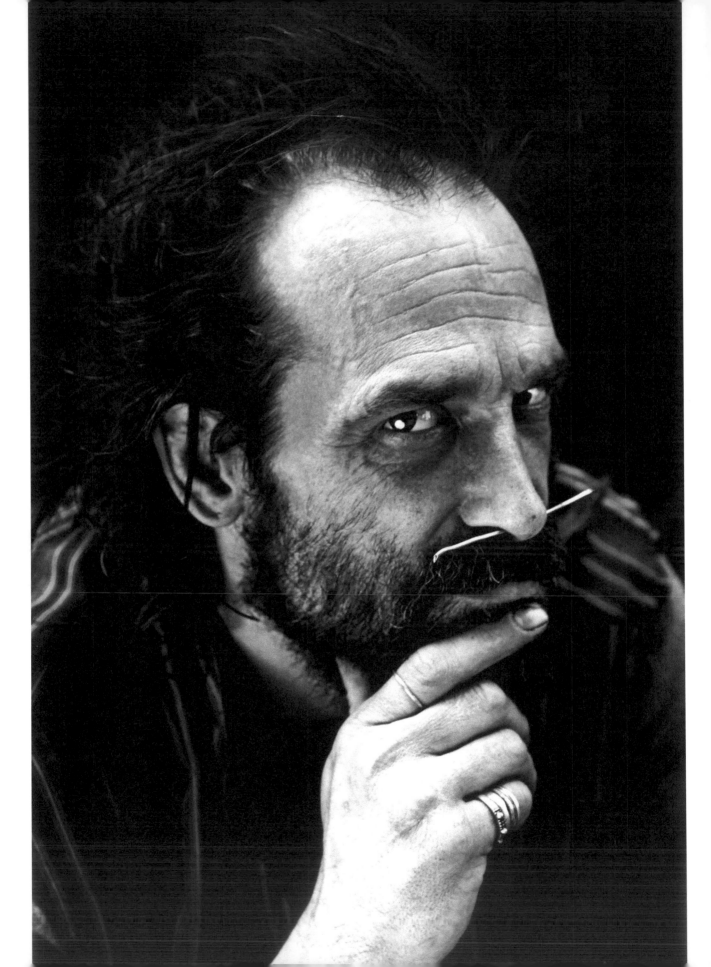

WAYNE

My dad and I stumbled upon Wayne on our way to the St. Patrick subway station in Toronto. It was an unseasonably hot April day, and he looked laid back and relaxed in shorts and sandals.

Wayne and I immediately took to each other. This was in part, I think, because we both had nose piercings (though mine was really just a fake nose ring). Wayne was quite proud of his piercing and even took it out to show me.

When I told him of my goal of pursuing photography for a living, Wayne was very encouraging.

"Don't let anything deter you from following your dreams," he said.

He even very kindly offered to give me a photo backdrop that he—surprisingly—just happened to have on hand. However, I had to decline his gift as it would have been too big and heavy to carry around.

 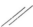

BILL

Bill was about 50 metres away when my dad and I first spotted him. He looked forlorn as he sat on the sidewalk beside the Eaton Centre on Dundas Street in Toronto. With his back against a huge white lit-up sign, he was difficult to miss.

Bill agreed to let me take his picture, but when my dad asked him a few questions—"Are you enjoying the nice weather?" and "Have you lived in Toronto long?"—he just nodded his head.

Throughout the whole photo shoot, Bill never uttered a word.

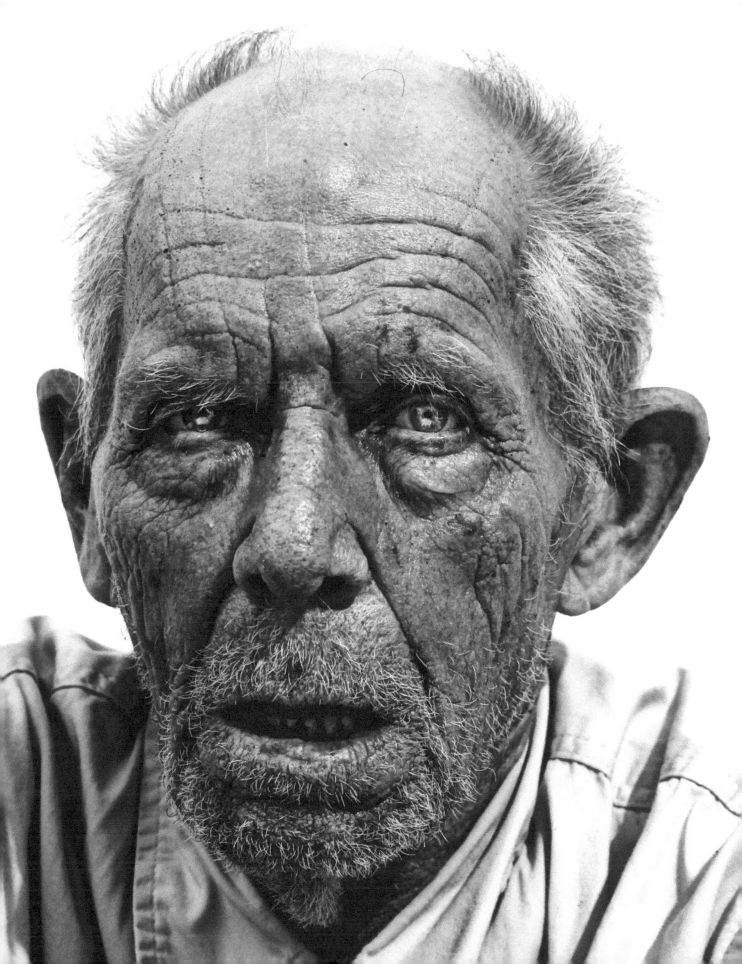

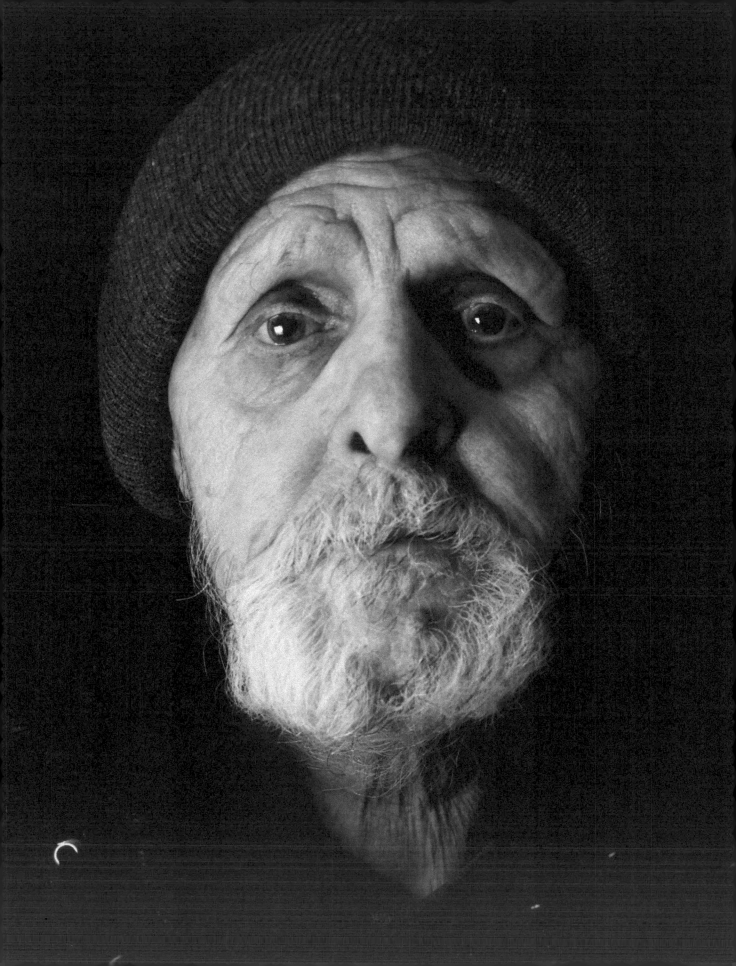

DON

Don is a card. He likes to entertain and make people laugh. During our ten-minute photo shoot, there was constant laughter and jokes.

"When I'm joking around and talking to people," he said, "I make lots of friends."

When we met Don, he was living at the Barrie Bayside Mission Centre. His dream, however, is to move to Newmarket, Ontario, and open a store.

"Maybe jokes and novelties on one side, and t-shirts on the other, as well as coffee and tea—no pastries. There will also be a coin-operated pool table for the kids." Ideally, he said, he'd like to find a lady friend to help him run the business.

"Why Newmarket?" my dad asked.

"I've lived at the Newmarket shelter before," Don said. "So, I thought that would be a good spot. Not here."

However, his main reason for wanting to move to Newmarket came out later in our conversation when he said he wanted to find his youngest daughter.

"She's in Toronto someplace. That's why I came to this place again, looking for her. I thought, 'If I get to Newmarket, I'll be close.' I haven't seen her for over 20 years. My young daughter." He has another daughter who lives in Minnesota.

Despite living at a shelter and being separated from his family, Don has a positive attitude towards life. When my dad asked him "What makes you happy?" he exclaimed, "Everything!"

DAVID

You may recognize David by the tattoo on his arm that says Lucky One. He's the man in the photograph titled *Homeless Man and Dog*.

My dad and I came across David while vacationing in New York City in August 2016. He was sitting with his dog—a dog that he'd rescued—on the sidewalk at the corner of 58th and 7th.

David was sitting beside the beautiful, historic Petrossian Restaurant, one of the most luxurious restaurants in all of New York City. The striking contrast between the opulence of the building, covered with ornate terracotta ornamentation in the French Renaissance style, and the dire poverty of the man sitting beside it was hard to ignore.

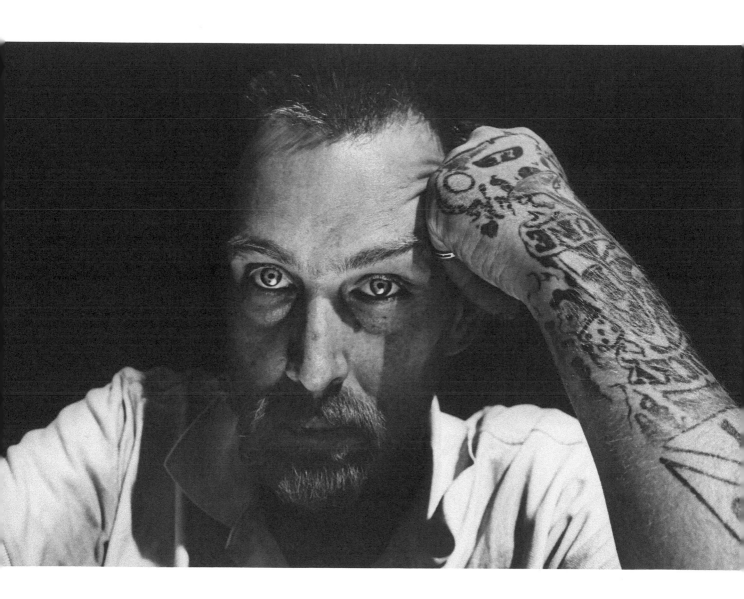

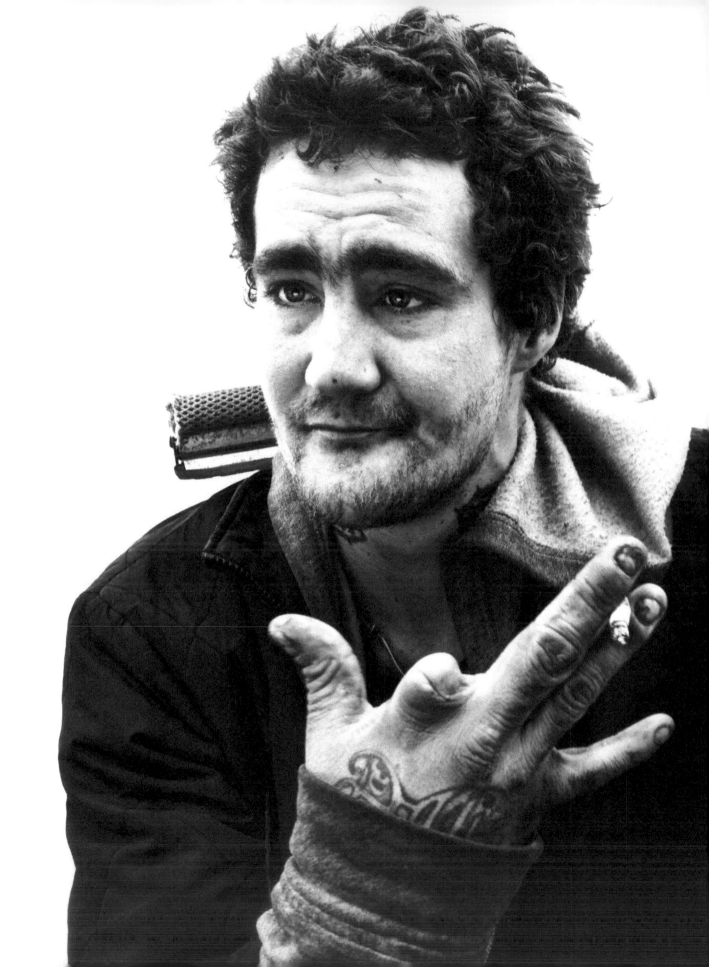

RHYLIE

Rhylie, who is called "Foreigner" by his friends, owes his life to an incident that, unfortunately, resulted in his losing the index finger on his right hand. Here is how the incident occurred:

"I overdosed on a drug called fentanyl. It's the most powerful opioid, man-made opioid. And I had a candle between my two fingers when it happened. The candle melted onto my finger. I had what's called fourth-degree burns. I came to because of the pain. It didn't get infected or anything ... but they had to amputate. But if I hadn't come to, I would have died. The pain acted like a shot of adrenaline that revived me."

Because of this, Rhylie now wears a Life & Death tattoo on his injured hand. Right-side up, the tattoo says Life. Upside-down, it says Death. Rhylie's girlfriend, Lucy—pictured elsewhere in this book—helped redesign the tattoo. She changed the skull into a flower, to represent growth, and added a heart, signifying rebirth.

The loss of a finger has not stopped Rhylie from being able to make money washing car windows on the streets of Toronto. The day after I posted this photograph online, a person commented that Rhylie had just, a few hours earlier, washed his car windows when he was stopped at a traffic light.

DON

It was a hot, humid day in Kitchener, Ontario, in the summer of 2015. My dad and I came across Don talking to friends in front of a store, just down the road from the historic Walper Hotel.

Don, I discovered, is a person of few words. He was wearing a cap which cast a shadow over his eyes, so I asked him politely if he would remove it. I snapped this photo just after he had taken his cap off and was combing his fingers through his long, grey hair.

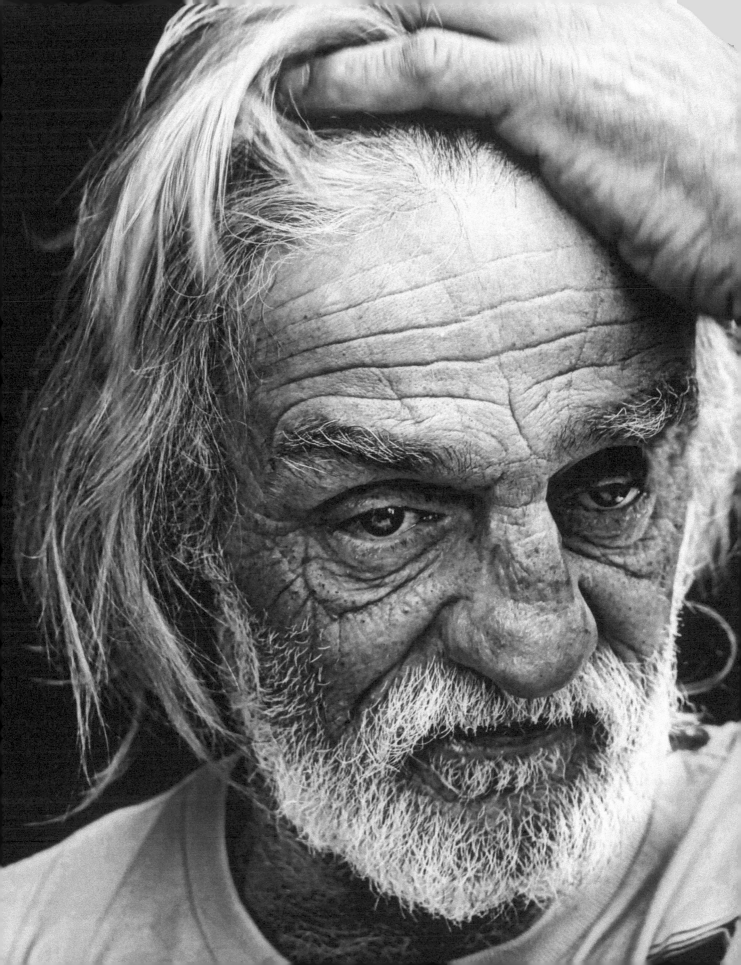

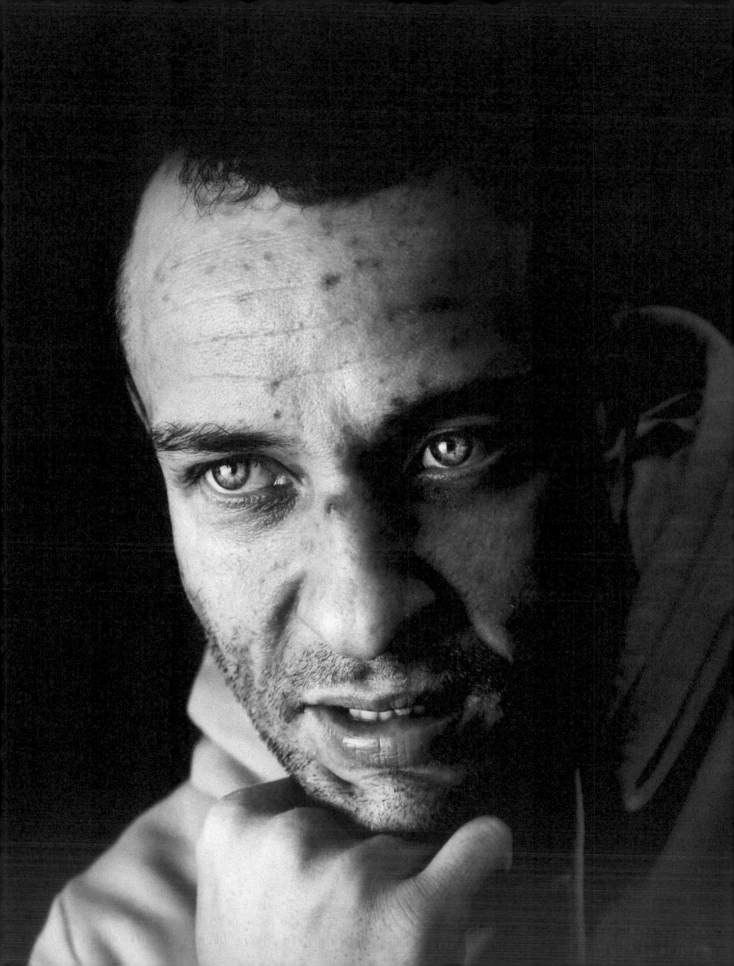

DARREN

When we met him, Darren had been staying at the Barrie Bayside Mission Centre for the past six weeks. It was his home now. Before that, he had lived off-and-on with his parents, but this came to an abrupt end as a result of a dispute.

"I disrespected them too much," he said. Nonetheless, he stays in constant contact with them. "My mom is my best friend."

When we met Darren, he was in a particularly good mood. Three days earlier he'd been able to move into his own room. This had clearly made his day, if not his week. "It's kind of a big thing. You feel a little more human."

Although Darren has lived in Barrie for 17 years (he's now 35), he has recently come to see the need for a change.

"I don't particularly like it here anymore because I'm an addict, and everywhere I go, there seems to be someone I know." Eventually, he would like to "fix myself up" at a drug treatment centre and then move to another city.

One of Darren's biggest challenges is judgmental people. "Most people who don't know me are scared of me, because I have a certain look to me. But I'm a very nice person. You just have to get to know me and not let my looks scare you."

Darren spoke to us with candour. When we asked him what makes him happy, he replied, "To be honest, I've been lost for so long I don't know." When we asked him where he sees himself in five years, he said with brutal honesty, "I just hope to be alive."

THE BEGGAR

My dad and I came across this man while he was begging on a street in New York City in August of 2016. An upturned hat sat between his feet.

He appeared to be sleeping so, not wanting to disturb him, I snapped a couple pictures as we walked by. I thought the man looked so despondent. But, maybe, he was only taking a much needed nap.

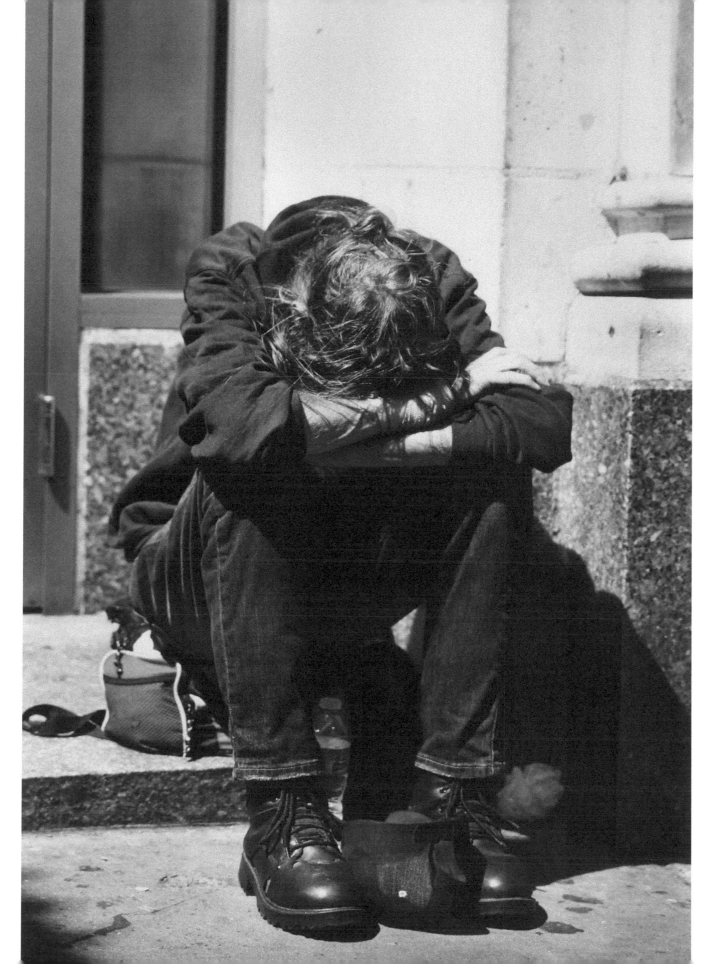

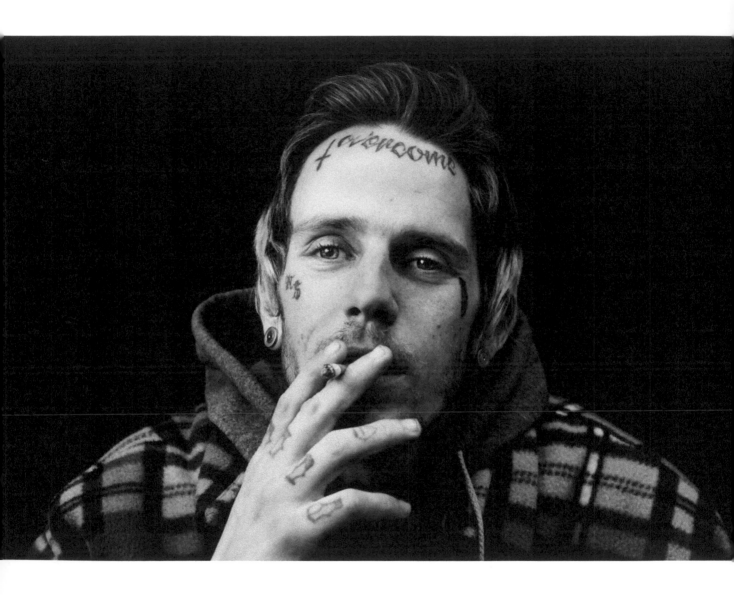

DOREIN

Dorein is a native of Nova Scotia. He moved to Ontario to find work. "There is no work in Nova Scotia," he said. First Dorein settled in a small town in Muskoka. After losing his job, he moved to Barrie hoping that, since it was a bigger community, there would be more job opportunities. Little did he know that, a year later, he'd find himself with neither a job nor a home. "I'm just trying to find my way," he said.

What Dorein enjoys more than anything else is art—"I love art." The kind he likes most is body art, especially tattoos. Dorein likes tattoos so much he does his own. When asked where he tattoos himself, he replied, "Anywhere I can get to." I wonder if his dream job would be working in a tattoo parlor.

When we came across Dorein, he was staying at the Barrie Bayside Mission Centre. Even though things haven't panned out for Dorein, he's managed to keep a positive attitude towards life. This is clear from the tattoo emblazoned across his forehead, which says: Overcome.

DAVID

After getting out of bed, one of the first things David does is walk the two blocks or so to McDonalds on Dundas Street West in Barrie for his morning coffee. He does this alone. He has no family around and few friends. But while many people would find such a situation unpleasant, to say the least, this is not true of David. In fact he prefers it this way. Like the character in Neil Diamond's 1960s hit song, David is a Solitary Man. "I'm a loner," he told us. David is 60 years old.

When we met David, he was living at the Barrie Bayside Mission Centre, but his goal is to one day get a place of his own. "Not a house. Just an apartment. I don't plan on being homeless for very much longer." That's not to say he isn't happy at the centre, for he is. "The staff are good, and the food is awesome. It's also warm," he added with a chuckle. It's just that he would rather have a place of his own.

As well as being a solitary man, David is also laid back. He lives life in a relaxed manner. Although he receives a pension, David works every once in a while, when the urge comes on him. "I occasionally go down to Labour Ready in the morning when I feel like working." Labour Ready, he explained, is an agency that provides day labour for such things as construction, hospitality, and landscaping. "There's no commitment," he said.

And that's just the way David likes it.

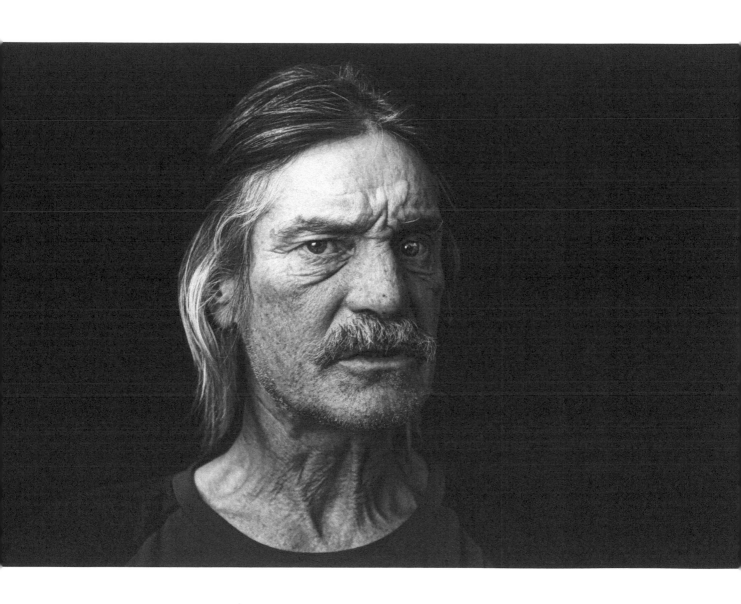

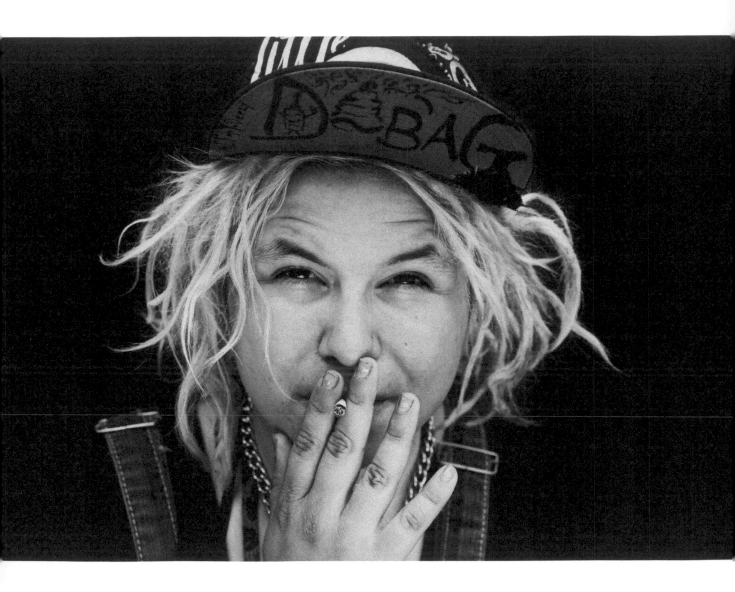

JEN

Jen had made herself at home on the northeast corner of Yonge and Dundas in Toronto when my dad and I met her. She was sitting a few feet from the curb on a blanket she'd spread across the sidewalk. Scattered across the blanket were several items—a backpack, a water bottle, and some bags. She was sitting there, Buddha-like, on her blanket, smoking a cigarette, appearing, like the sage himself, indifferent to the world.

When my dad asked if she'd be willing to model for me, Jen said, "Sure, as long as I can keep smoking."

"I wouldn't want it any other way," my dad replied.

Jen came across as, somewhat, defiant. On her bleached blond hair, she wore a cap with the word D-BAG written on it. Around her neck, she wore a heavy chain necklace with a padlock, which, she said, she couldn't remove as she had lost the key.

JOHN

John is 40 years old. When we met him, he'd been staying at the Barrie Bayside Mission Centre for three months. Before this, he'd lived in Windsor, Ontario. When my dad asked what brought him to Barrie, John replied, "I'm just trying to find a good place to settle down." However, a few moments later, he revealed that he'd moved, primarily, to be closer to his mother.

John's goal is to find a permanent, full-time job.

"I would like to be working as a custodian," he said. In the meantime, he's content to stay at the shelter. "I feel safe here."

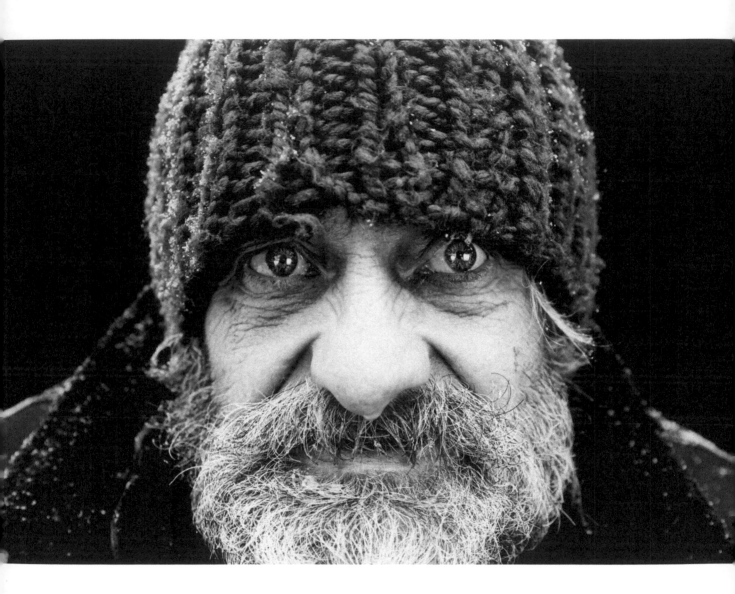

GRANT

It was a cold, blustery winter day. As we started walking north on Bayside Street towards Dunlop, my dad noticed Grant sitting on the steps of a business across the road from the Barrie Bayside Mission Centre. When, 45 minutes later, we returned half-frozen to our car, my dad saw that Grant was still sitting in the exact same spot—in minus 15 degree weather, and with bare hands.

Grant agreed to have his picture taken and answer a few questions. The first question my dad asked was, "Aren't you cold?"

"You get used to it." Grant told us he was staying at the Centre.

"Do you like it there?"

"They are always kind to me," Grant said, "and treat me with respect, which is more than I can say for those who see me on the street."

Grant wound up on the street when his request for ODSP (Ontario Disability Support Program) was turned down. Fortunately for Grant, his plea for help from the good people at the Barrie Bayside Mission Centre was not similarly rebuffed.

THE BAG LADY

While standing at the busy intersection of Yonge and Dundas in Toronto, my dad and I noticed a woman walking north along Yonge Street. Despite it being the middle of summer, she had on a winter coat and hat, as well as a scarf and gloves. She was stooped over, pushing a walker filled with bags. She moved at an extremely slow pace, shuffling without lifting her feet.

My dad approached her to ask if I could take her picture. She immediately became agitated and started flailing her arms around in the air, yelling, "Aaaaa! Aaaaa! ..."

We stood, watching her shuffle slowly away. Isolated and alone, the woman appeared very vulnerable. As she crossed Yonge Street, the light turned green while she was still in the middle of the road. Fortunately, the drivers waited patiently until she was completely across the road before advancing.

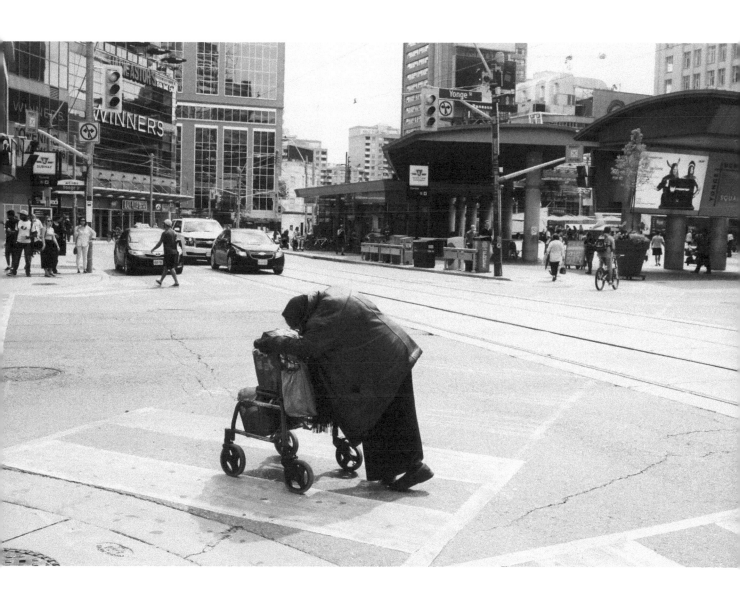

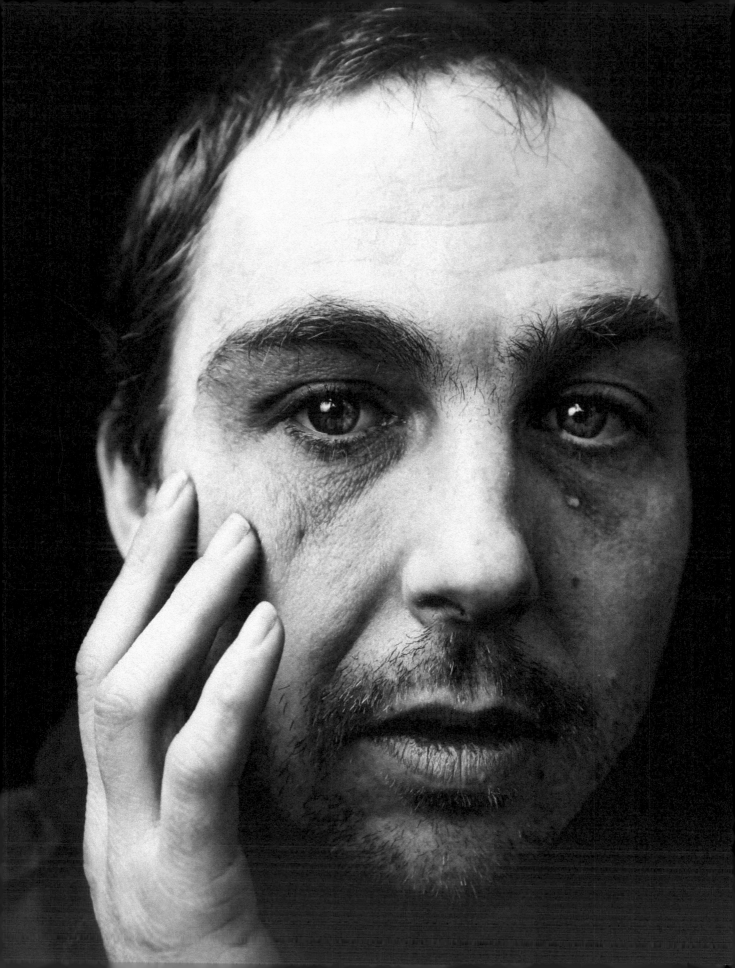

ANDREW

The day before we met Andrew at the Barrie Bayside Mission Centre, he had lost two of his friends in Toronto. "One got shot and the other got stabbed," he said. When my dad asked if he'd considered getting counseling at the centre to help him with his grief, Andrew replied, "What good can counseling do? It's been a repeated cycle my whole life."

For the past five years, Andrew has called Toronto his home. However, he prefers living in Barrie. And although his family also live in Barrie, he says they are not on speaking terms. "I don't talk to them," he said, his voice matter-of-fact.

Andrew's passion is cooking. He takes great pride in his culinary skills. "I'm the best cook." The staff at the centre are helping him realize his dream of working as a cook.

After the photo shoot, Andrew clutched my dad's hand and said, "Thank you very much for drawing attention to homelessness. I really appreciate that."

LESLIE AND MCLOVIN

Leslie found McLovin five years ago near St. Clair West and Silverthorn. "I found him starving beside the road," he said. "He was only about a week old. He and his two sisters had been living in a rooming house that was boarded up. Unfortunately, his sisters didn't make it. It was Halloween. So he's my little Scorpio."

McLovin is the most docile cat I've ever met. Nothing seemed to faze him. Not the crowds of people that streamed by. Not the strangers who constantly stopped to pet his head. Not the constant traffic that whizzed by just two metres behind him. Not even the musician who banged loudly on his drums five metres away. However, I noticed that he did get a little perturbed—though only slightly—when a big dog that belonged to a passerby stopped, momentarily, beside him.

Leslie is a reformed alcoholic. "I used to be a drunk," he said, somewhat hesitantly, "but I cleaned myself up." Now he's working towards getting his own apartment. "I have first month's rent already, and I'm close to getting last month's." In the meantime, Leslie and McLovin have been moving back-and-forth between a friend's house and the Seaton House homeless shelter.

When my dad and I met Leslie and McLovin, spring was in the air. My dad asked if he was looking forward to the warmer weather. "Yes," Leslie said, "this is the season where we change our whole lives." Eventually, Leslie and McLovin want to move to British Columbia where the temperatures are more agreeable.

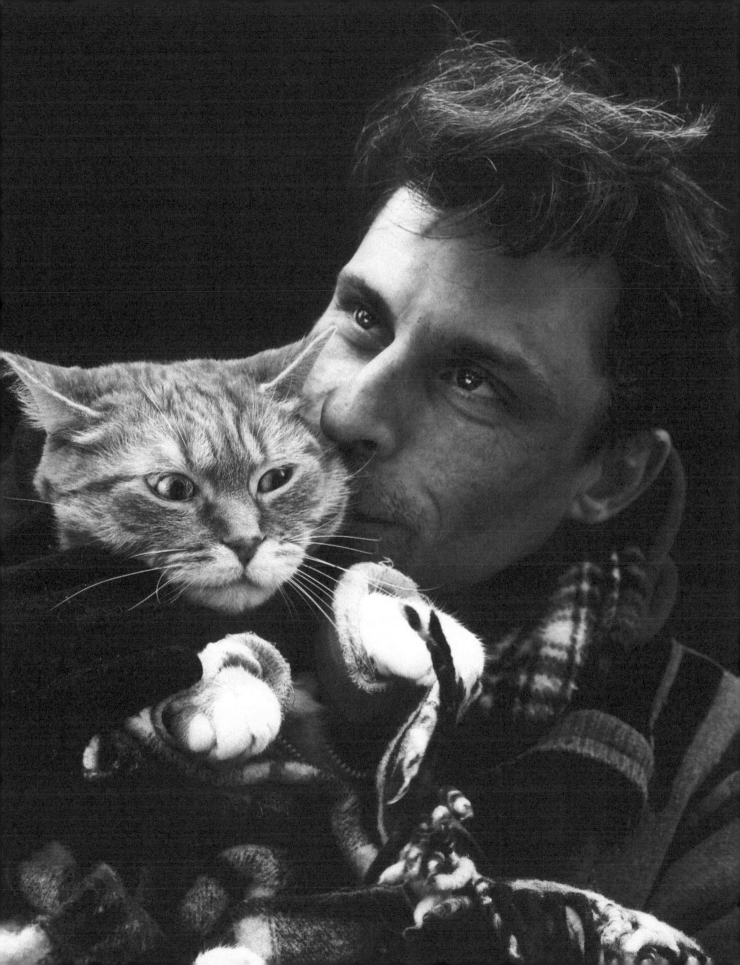

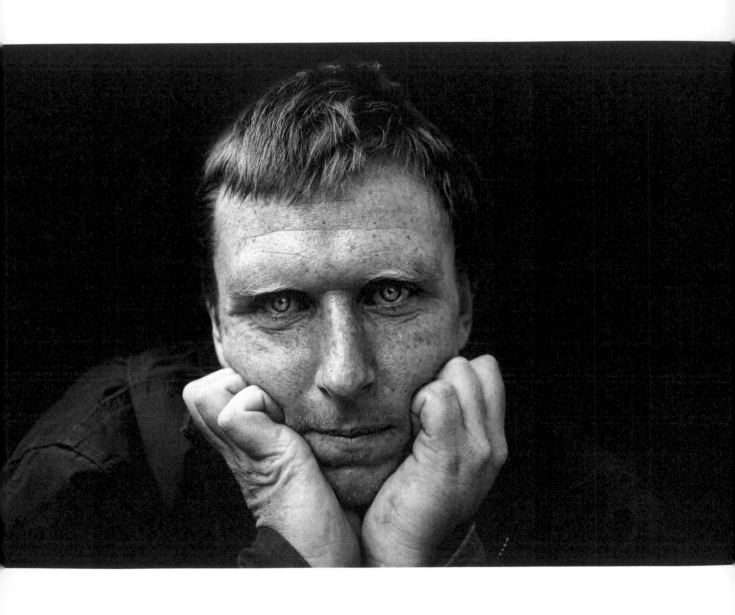

BRISON

Brison had been living at the Barrie Bayside Mission Centre for three weeks when we met him in March of 2017. When my dad asked how he liked it at the centre, Brison replied, "It's okay. There's a lot of conflict, but it's okay." Later, he revealed the most common cause of friction is drugs. And he should know. Recently, Brison moved to Barrie to get clean from an addiction to methadone. "I'm detox now completely," he boasted.

Now that he's clean, Brison's goal is to finish school. As well, he's hoping to get his own room at the centre. (He was sharing a dorm with five men.) Brison has also made a couple friends at the centre. This should help make his stay at the centre more tolerable, despite the conflicts.

RHYLIE AND LUCY

When we came across Lucy, she was rummaging through her things at the corner of Yonge and Edward in Toronto. She had made a spot of her own next to a utility box. As my dad and I stood watching her, Lucy seemed totally focused on what she was doing, oblivious to the crowds streaming past her.

After my dad approached Lucy about modeling for me, she asked excitedly, "Can you do my boyfriend, Rhylie, too?" When my dad answered that we could, Lucy bolted off down Yonge Street, looking for Rhylie. It took about fifteen minutes, but she finally found him.

Rhylie and Lucy (both featured individually elsewhere in this book) are from Timmons, Ontario. They met about nine years ago when Rhylie intervened to prevent Lucy's boyfriend at the time from hitting her. "I grabbed him by the throat and lifted him right off the ground," he chuckled. They became a couple about a year later. At the time, Rhylie had just broken up with his girlfriend and was going to detox. "So I was in a bad place," he said. Lucy was 23 years old and Rhylie was 22.

As a further show of his affection for Lucy, Rhylie tattooed the name of her child, Max, on the left side of his neck. He adopted Max. "So he's my boy too," Rhylie said with obvious pride.

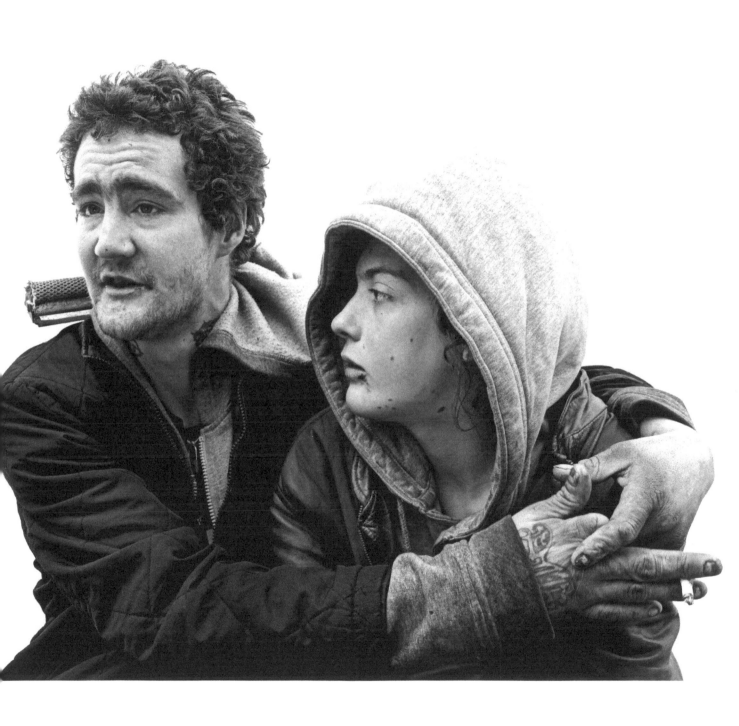

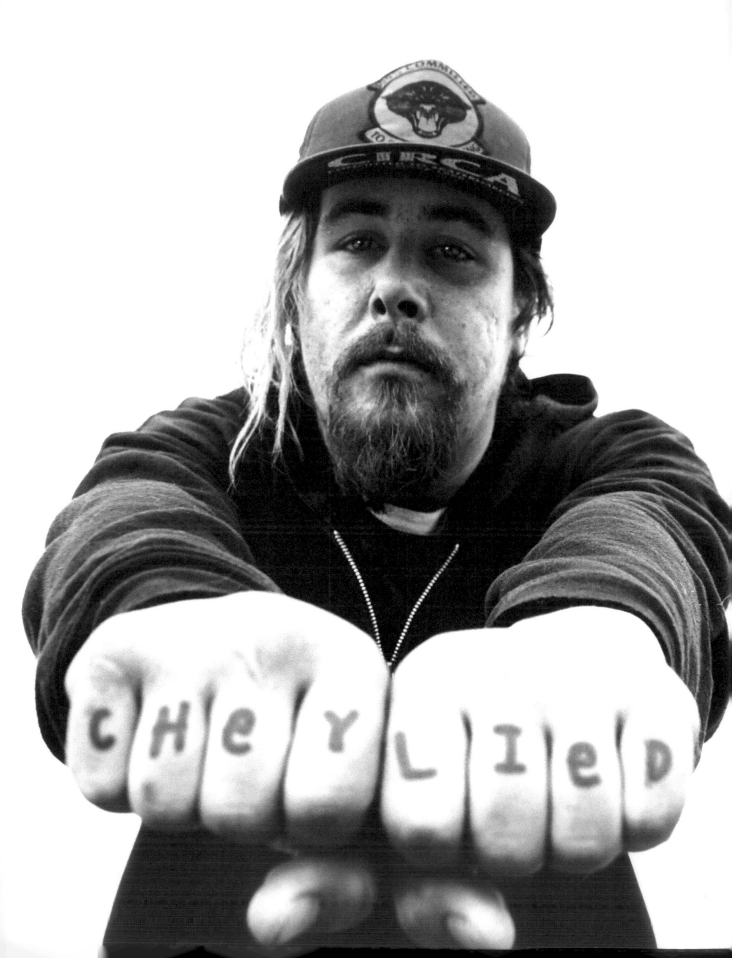

CHRIS

Chris is an angry young man. He is angry with his family for not standing by him. When asked about his family, he replied sarcastically, "What's *family*?" He added, "My family's my dog. My family's my friends. The people who stab me in the back and all those _____? You can forget about those people."

Chris is angry at his ex-girlfriend for running off on him when he was in jail. "I was going to go to Thailand and marry the girl. We were supposed to go to BC and make a bunch of money, and you know, like, live a good life. I got out of jail in Winnipeg, and she'd been cheating on me the whole _____ time."

Chris is angry at the Canadian legal system for, he says, unfairly persecuting him. "I have some really bad warrants. I had to get out of town because I'm sick of doing time. I'm tired of being arrested for things I didn't really do, for things that don't even warrant an arrest."

Chris is angry at life. "It sucks," he said, "because, look, I'm 28 years old and all my real friends are dead, and I'm stuck with a lot of _____ who stab me in the back." The jacket he's wearing, he told us, belonged to a friend of his who was killed on Halloween when he was struck by a Via Rail train.

And lastly, he says, he's angry at Chey for lying and getting a friend of his in trouble—angry enough to have the words Chey Lied tattooed on his hands.

KARL

Karl, known to his friends as "Bushman", is Mohawk, and his family are members of Six Nations of the Grand River. Six Nations, which is the largest First Nations reserve in Canada, is situated near the city of Brantford, Ontario.

Karl has been living on the streets of Toronto for six months. Before that, he lived in Nanaimo, British Columbia. "It took me six months to get to Toronto," he told us.

Although Karl's biological family belongs to Six Nations, when asked if he had any family in Toronto, he pointed to a Native American man sitting next to him by the name of Reko. "Him!" Karl and Reko are best friends.

"We carry each other all the time," Reko said.

When we spoke with Karl, it was a cool March afternoon with the temperature hovering around zero degrees Celsius. The winter, Karl told us, had been comparatively mild. He and Reko only used Toronto's Out of the Cold programs a few times. Nonetheless, he's looking forward to the warmer weather.

When my dad told him we were hoping to draw attention to the plight of the homeless through our book, Karl seized the opportunity to give us a message to pass on to Canada's politicians. Here it is: "We've got to do more about getting homeless shelters."

Note: Sadly, Karl died from cancer a mere three months after the photo shoot and interview my dad and I did with him.

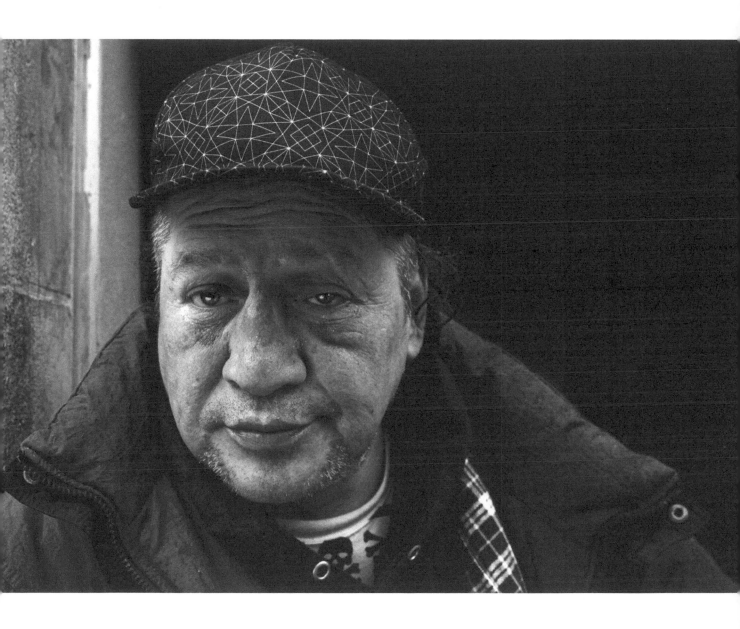

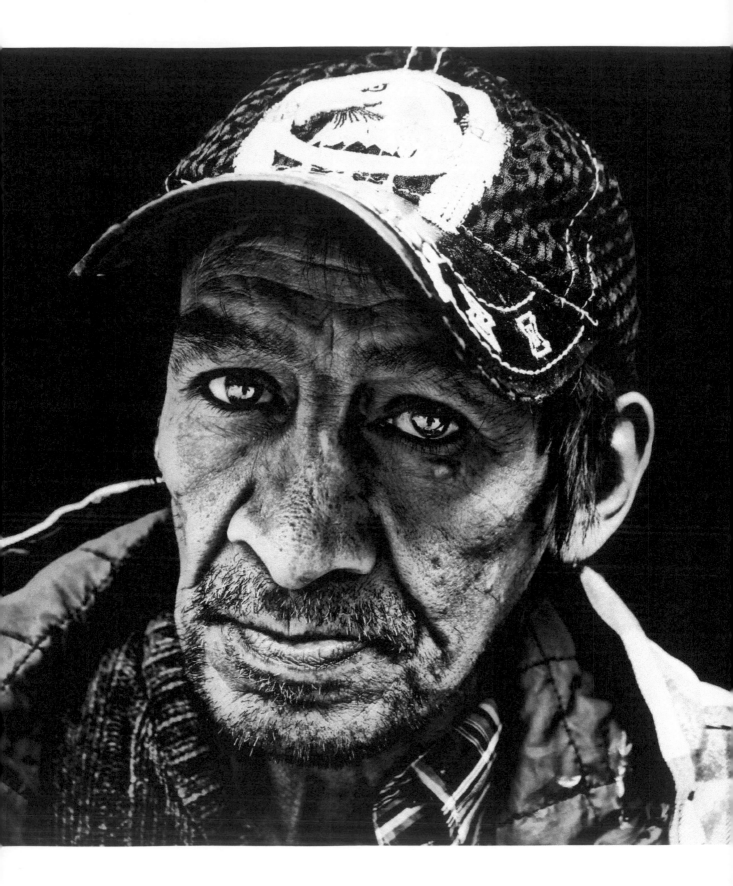

ANIK

Anik is an Inuit artist. When my dad and I met him in the summer of 2015, he was selling his finely crafted paintings on the sidewalk on King Street West in Kitchener, Ontario. Rendered primarily in red, black, and white, Anik's paintings glistened in the noonday sun.

We stood and watched him for a moment as he began work on a new painting, his hands covered in paint. Seeing our appreciative glances, Anik put down his brush and proceeded to tell us about each of his paintings. He was justly proud of his accomplishments.

When my dad asked him if I could take his photograph, he was more than happy to comply and even asked if I could photograph his paintings, which I did.

BOB

This picture of Bob was taken in Kitchener in the summer of 2015. It is one of my first portraits of a homeless person. At that time, I had no thought of making a book and didn't record our conversation. While I don't remember a lot about Bob, I do remember he was very friendly and had a smile that lit up his whole face.

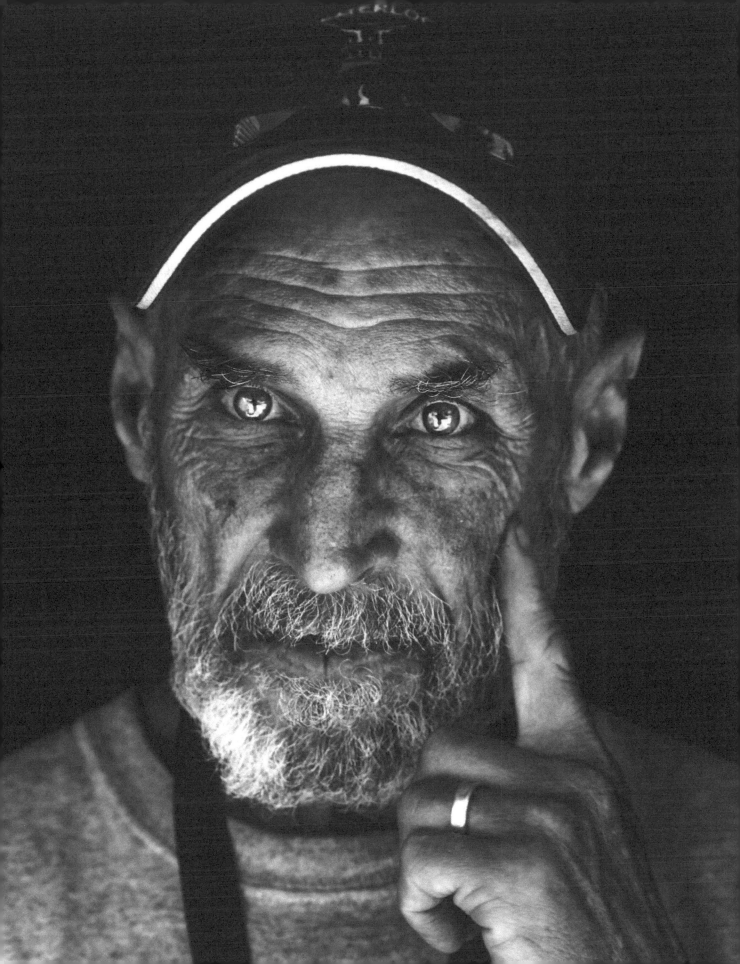

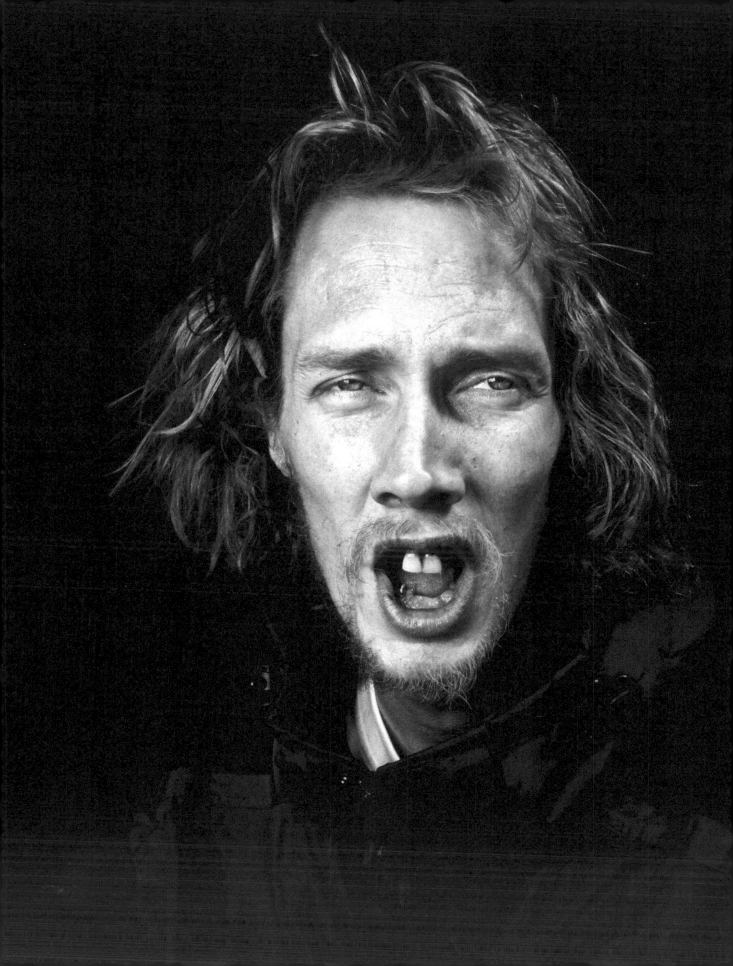

GEORGE

It was a warm April afternoon when I took George's photograph at the corner of Yonge and Edward in Toronto. When asked if he was happy to say goodbye to winter, he replied, "I was done with winter a week after it started. I'm a spring and fall man. Summer's too hot. Winter's too cold."

My dad asked why he didn't make his way to a warmer province, like British Columbia. George answered that although the climate in Canada's westernmost province was more agreeable for those like him who are homeless, the same cannot be said about the people there. "I've noticed that the nicer the weather the more, I don't want to be rude, but the more ignorant people become. They just pretend you don't exist."

My dad explained that one of the goals of our book is to humanize the homeless. "What a lot of people don't realize," George said, "is that homeless people are just like everybody else. We're humans!"

George told my dad that he refuses to stay at homeless shelters. "I don't trust the shelters. It's not the staff. It's the clients, the other homeless. A lot of homeless people have no respect for their fellow homeless." Once, he said, while he was sleeping in a shelter, someone tried to steal the underwear from right off of him. That's why, when the temperature gets really cold, he retreats to a house of a friend or a family member, never a shelter.

KODIE

Kodie is a squeegee man. When we met him, he was hard at work washing car windows at the busy intersection of Yonge and Dundas. When my dad asked if he makes much money doing this, Kodie thought for a while before saying, "Yeah."

Although Kodie has lived in Toronto for a couple years, he's originally from Trenton, Ontario, a well-known Canadian Forces base. Kodie was dressed in army fatigues, and my dad thought he'd at one time enlisted. But Kodie said although he'd once wanted to join the army, he was unable to because of his criminal record.

When it gets really cold, Kodie said, "I go to St. Margaret, if anything." St. Margaret New Church is a men's hostel in Toronto that operates out of St. Margaret's Church.

Kodie is a soft-spoken man who chooses his words carefully. When my dad asked what he hopes to be doing in five years, Kodie thought long and hard before answering, "I don't know."

"You haven't thought that far ahead?"

"No, not really."

Kodie proudly showed off his many tattoos. He was especially proud of one of Mary, the mother of Jesus. She is crying. Underneath is a quote, spoken by the prodigal son to his father: "Forgive me ... for I have sinned."

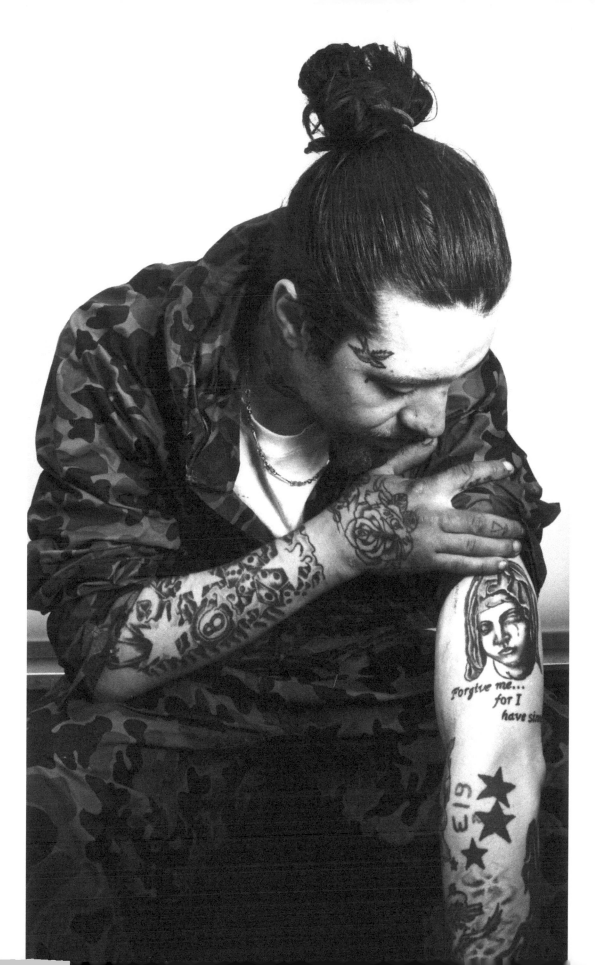

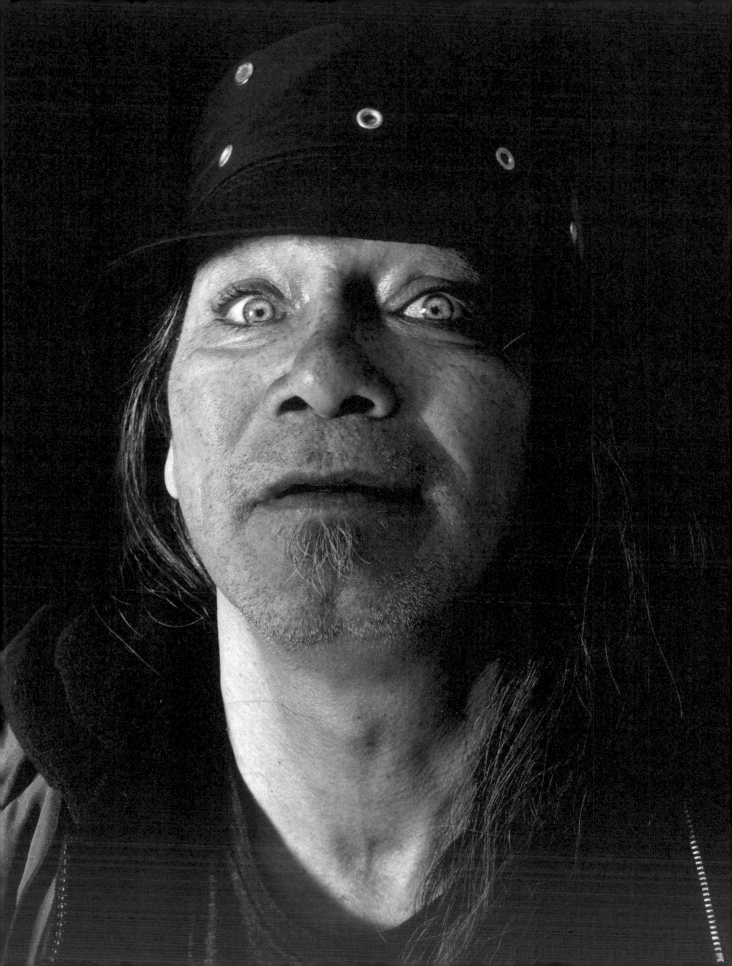

TWO FOX

When we met Two Fox, he was sitting with a couple of his fellow First Nations friends on Yonge Street in Toronto, just north of the Yonge and Dundas intersection. He told me that they watch each other's backs. He said, "One's ex-marine, I'm ex-army, and the other one's crazy." He and his friends feel a moral obligation to keep a watchful eye on the streets of Toronto. "It's part of our responsibility to be here as well, and keep the streets clean, keep things up, you know. Don't let the rotten things happen. It's what we're trying to do here."

Two Fox did not seem to mind the cold winter nights in Toronto. He can tolerate sleeping outside most winter nights but has to find shelter when the temperature drops to minus 15 degrees Celsius. "It's hard because I'm full of arthritis and broken bones, things like that," he said.

Two Fox makes Ojibwe art. "I carve, paint, make jewelry, dreamcatchers, regalia for all of the other dancers." He sells his work at his cousin's gallery. "I helped her start it," he said, "and donate paintings to help her keep going."

PETER

It was a hot August day in New York City, and though it was late in the afternoon, heat still radiated from the asphalt and sidewalks. We saw Peter sitting beside a busy street, his face in his right hand. My dad approached him, introduced us, and asked if I could take his picture. There was no response. Again my dad put the question to him. This time, without opening his eyes or lifting his head, Peter gave us permission with an ever-so-slight nod of his head.

During the next five minutes, Peter never moved a muscle. Like Auguste Rodin's sculpture *The Thinker*, he sat motionless. Everything about him—the way he held his face in his hand, his expression, his body language—gave us the impression of a young man who was despondent.

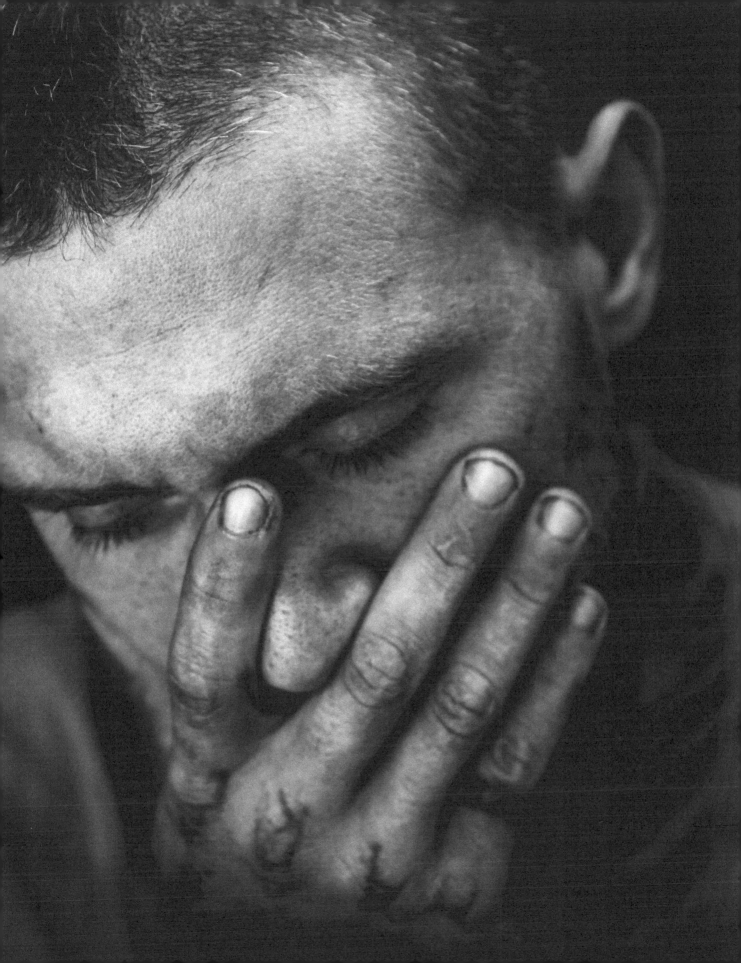

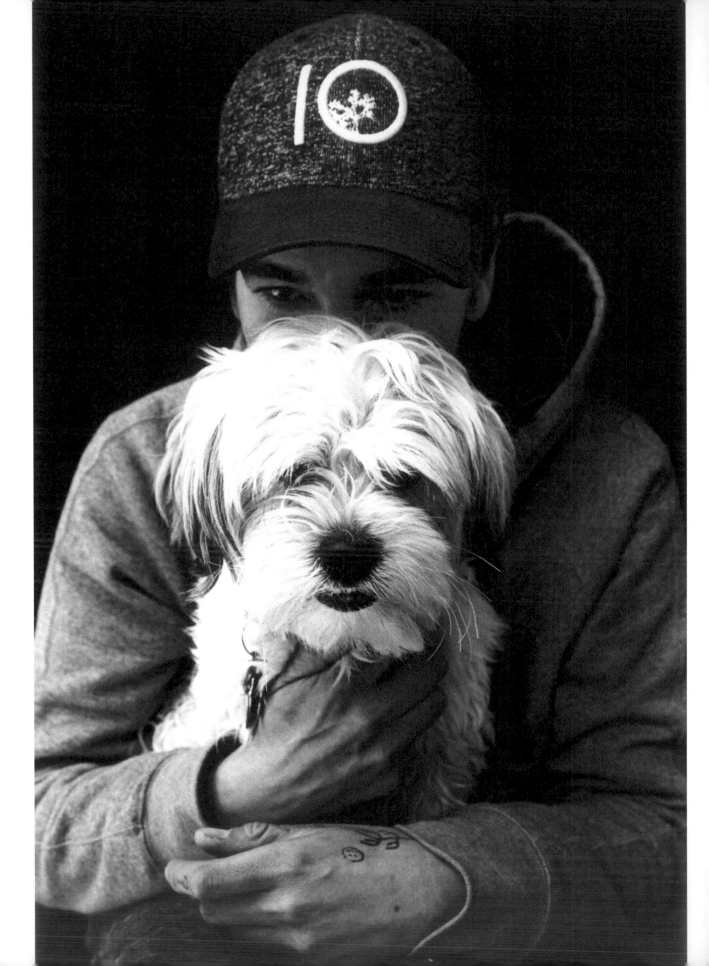

TREVOR AND FINNIGAN

Trevor is just biding his time until he can once again do what he loves most: work on a charter fishing boat.

"Well, I do charter fishing on the lake, right. So hopefully in the summer I can start that up again," he said. "I can stay on the boat, right. In the summer, like, when it gets hot we've got to go right out. The blue zone we call it. It's 400 feet. That's an hour drive out there, 14 kilometres out. Good salmon fishing though."

"So you, obviously, enjoy it, then?" my dad asked.

"Oh, I love it! I love it!"

In the meantime, Trevor usually sleeps on the streets—or, more precisely, on the Sunnyside Beach in Toronto, where he slept the previous night. My dad asked why he didn't stay at a shelter.

"I can't go to any shelters or Out of the Cold programs with him," he said, nodding in the direction of his dog, Finnigan. "So I've been sleeping outside ... He's pretty good, though. He goes right into the sleeping bag and sleeps at my feet. I can't leave him. If I leave him, he freaks out."

"Do no shelters in Toronto allow animals?"

"There's one up on Caledonia that takes dogs. Bethlehem United Shelter, I think it's called. It's the only place, and it's always full."

The website of Bethlehem United Shelter says they realize how important it is for homeless people to own pets, since, for many, they are their only friends. The love that Trevor and Finnigan share was plain to see.

"I've had Finnigan for six years. Since the day he was born. I was the first person to hold him...."

RON

While photographing Ron we were driven away by the staff who worked in the stores we were standing in front of—not once but twice. One person said we were scaring off customers.

"They're like that here," Ron said. When asked if this kind of thing happened to him a lot, Ron replied, "Yeah."

Ron has lived in Toronto for ten years. Before that, he lived in Newmarket. He said he has no family here. They all live in the small town of Sutton, about 75 kilometres north of Toronto.

The photo shoot was done on a beautiful, warm afternoon, late in April. When my dad asked if he was enjoying the nice weather, Ron answered, "Yeah, it's nice and warm." He's no fan of the winter. "I go to the Out of the Cold program. I don't go outside."

After we were driven away by staff for the second time, Ron got up to leave. But not before saying, "Alright, you guys, have a good day."

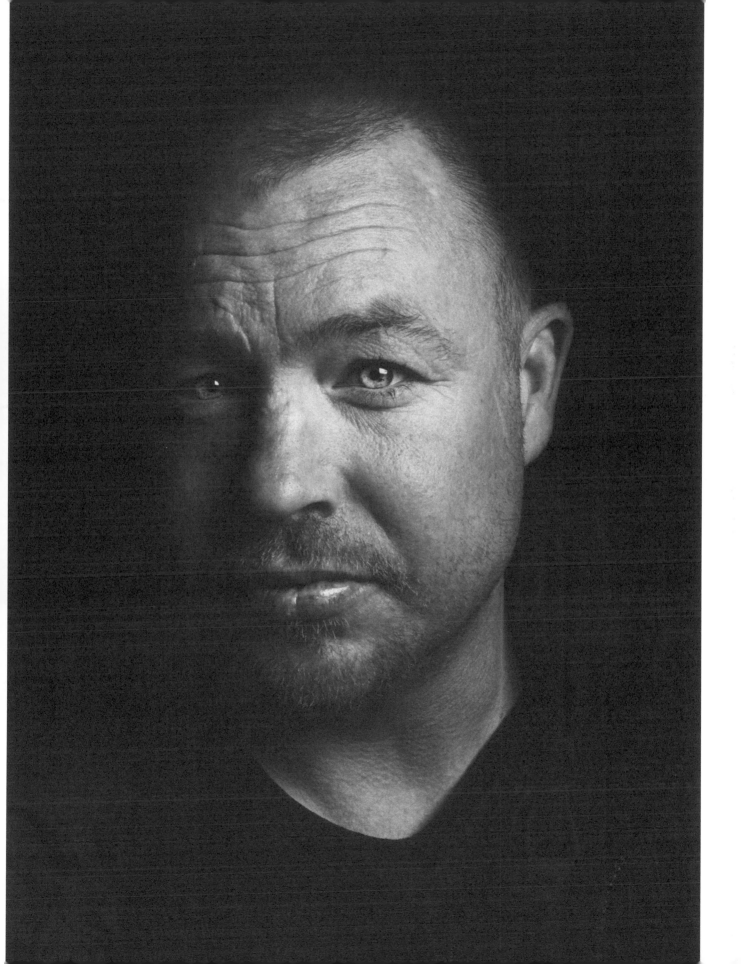

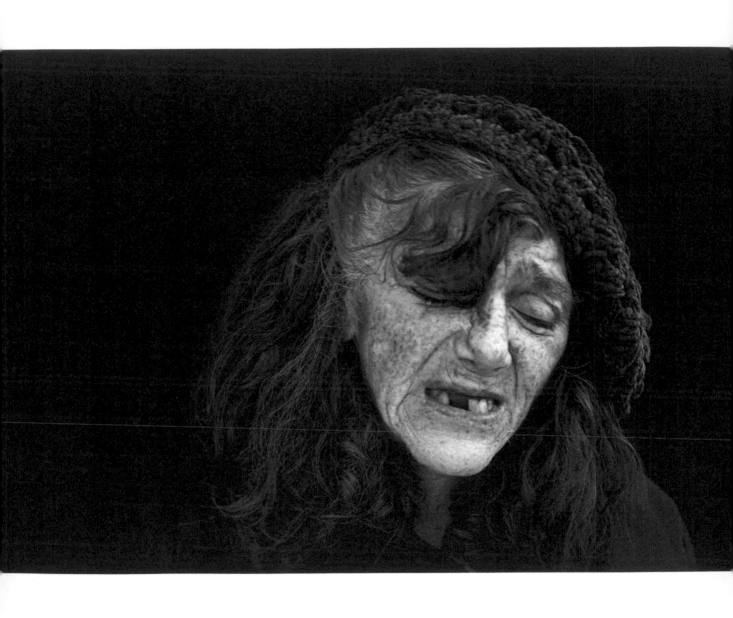

KATHRYN

Kathryn was talking with a couple friends beside the World's Largest Bookstore (since demolished) when my dad and I walked up and introduced ourselves. It was about one in the afternoon, and though winter had come and gone, there was still a chill in the air.

Kathryn was delighted to model for me and welcomed the attention. She said that she is of Scottish descent and, with her striking red hair and freckles, looked every bit the part.

"My name is Kathryn with a K", she told us. She spoke with much animation, expressing herself with her hands as much as with her words.

Although Kathryn was very personable and friendly, it seemed that life had not been easy for her. Her eyes conveyed a note of sadness. Speaking of her family, she said, perhaps half joking, "My sisters got our mother's blond hair, while all that I got was her arthritis."

When the photo shoot was over and it was time to say goodbye, Kathryn grabbed my dad's hand and said with obvious emotion in her voice, "It was so nice of you to do this. Most people just ignore me."

RESOURCES:
ORGANIZATIONS THAT HELP THE HOMELESS

Raising the Roof
raisingtheroof.org

Covenant House
covenanthousetoronto.ca

Salvation Army
salvationarmy.ca

Dixon Hall Neighbourhood Services
dixonhall.org

The Scott Mission
scottmission.com

Inn from the Cold
innfromthecold.org

Missionaries of Charity
peopleof.oureverydaylife.com/donate-missionaries-charity-6132.html

Hope Mission
hopemission.com

The Lighthouse
lighthousesaskatoon.org

Old Brewery Mission
oldbrewerymission.ca

Bissell House
bissellcentre.org

Home Horizon
homehorizon.ca

Coalition for the Homeless
coalitionforthehomeless.org

Homes First
homesfirst.on.ca

Young Parents No Fixed Address
ypnfa.com

I Have A Name
ihaveaname.org

The Jon Bon Jovi Soul Foundation
jonbonjovisoulfoundation.org

Horizon House
horizonhouse.cc

St. Francis House
stfrancishouse.org

Habitat for Humanity
habitat.ca

Leah's striking photographs sent chills down my spine. If we allow ourselves to be vulnerable to these stark and haunting images, soon we find that they are our aunt, our neighbour from down the street, a childhood classmate—they are us and not "the other." She has truly captured the beauty, joy, and pain of what it means to be human—a trait which, incidentally, we all share in common. I find it equally compelling that a 16 year old from Collingwood, Ontario, would choose to take the time to capture the narrative of the invisible and make them visible.

—GARY ST. AMAND
Chief Executive Officer, Bissell Centre

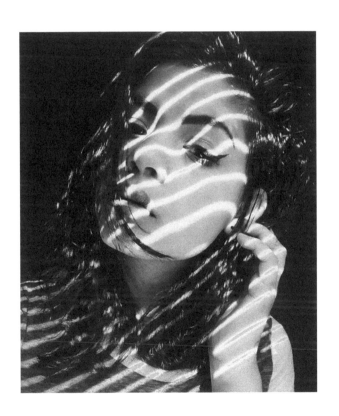

BIO OF
LEAH DENBOK

Leah Denbok has been taking photographs since she bought herself a used Canon EOS Rebel T2i from a local hockshop in the summer of 2012. Inspired by the work of British photographer Lee Jeffries, she has been concentrating on high-contrast portraiture. One of her photographs was awarded first place in the Blue Mountain Foundation of the Arts Juried Art Show. She was recently the subject of a mini-documenary that aired on CBC's 'The National'. Leah is thankful for the mentorship of National Geographic photographer Joel Sartore. "Without his encouragement," she says, "this book would have only been an idea." Through her photography, Leah wishes to help humanize the homeless and draw attention to their plight. She lives in Collingwood, Ontario, with her parents, Sara and Tim, and her older brother, Daniel.

To see more of Leah's photography, visit her website at:

www.ldenbokphotography.com

CPSIA information can be obtained
at www.ICGtesting.com
Printed in the USA
LVHW07s1503270318
571327LV00018B/300/P